Controversies in Sociology
edited by
Professor T. B. Bottomore and Dr M. J. Mulkay

6
The
Liberation
of
Women

Controversies in Sociology

The Liberation of Women

A Study of Patriarchy and Capitalism

by

ROBERTA HAMILTON

Concordia University, Montreal

London
GEORGE ALLEN & UNWIN
Boston Sydney

First published in 1978

© George Allen & Unwin (Publishers) Ltd, 1978

ISBN 0 04 301085 7 hardback
0 04 301086 5 paperback

Printed in Great Britain by
Biddles Ltd, Guildford, Surrey

Acknowledgements

This book grew out of my intellectual, emotional and political involvement in the Women's Liberation Movement. In that important sense I owe this book, and much more, to the women who preceded me and the women with whom I have shared the experiences of the last few years.

There are also more particular debts. Together, and yet in their very different styles, Professors Hubért Guindon and Kurt Jonassohn made me believe that this study was worth pursuing. Their enthusiasm, critical support and more tangible sorts of assistance were consistent with what their students have come to expect from these able, committed and kind teachers. I am grateful to Shirley Ciffin and Professor Vivienne Walters for their participation in the development and clarification of my ideas, to Susan Doughty for preparing the typescript with her usual care and precision, and to Tom Bottomore for his encouragement and his helpful editorial suggestions.

Susan Russell has shared my interest in this subject; her parallel research, critical analysis and her emotional and practical support have spared me from any sense of isolation in my work. She is my sister twice over and it is to her that I dedicate this book with love.

Contents

Introduction

This inquiry has been provoked by two related questions which, having surfaced periodically for centuries, have been asked more systematically with the development of the Women's Liberation movement in the last decade. First, why have women occupied a subordinate position in society? Second, how can the variations in form and intensity of that subordination be explained?

Within the Women's Liberation movement there have been two different interpretations which have usually been viewed as opposed: a feminist and a Marxist. The feminist analysis has addressed itself to patriarchal ideology, that ideological mode which defines the system of male domination and female subjugation in any society. Like other ideologies, it is instilled through socialisation and maintained by institutional methods (Mitchell, 1971, p. 65). But it differs in one crucial respect. It is predicated on biological differences between the sexes, giving it a materialist basis of its own. The feminists have, therefore, insisted that patriarchal ideology cannot be seen simply as part of the superstructure.

They have a persuasive case. Why not biology? It is the one persistent factor in all cultures, classes, time and space. Citing the time and energy involved in menstruation, pregnancy, childbirth, nursing and child care, Shulamith Firestone concluded that 'unlike economic class, sex class sprang directly from a biological reality: men and women were created different, and not equal' (1970, p. 16). Stories of healthy peasant women giving birth to healthy babies in the fields are largely apocryphal; the high female mortality rate from childbirth throughout history is not. No respector of affluence or power, childbirth was a frequent, inevitable, high-risk activity for women. Periods of dependence after childbirth and low mobility during nursing combined to ensure that women would need to rely on men for a large part of their adult life.

The feminist strategy for overcoming patriarchy stems logically from its analysis. Birth control, abortion and finally test-tube babies will provide the material basis for overcoming the limitations of female biology. The family, once necessary to provide

for woman during her periods of dependence, will crumble; men, women and children will love freely; the distinction between affection and eroticism will cease to exist as the need to confine the latter withers away. Furthermore, since all other class and racial antagonisms grew out of, and are reducible to, that initial inequality between men and women, a strike in the marriage beds of the land would be a threat not only to sexism but also to its byproducts racism and the class society (Firestone, 1970, pp. 43–5, 103–21).

It is difficult to imagine an analysis which provides an adequate explanation for the position of women that does not deal with biological differences. All societies make something of menstruation, whether magical, fearful, unclean or debilitating, in addition to the associated physical discomforts which vary from woman to woman. No society until our own has had the technology to control conception. Women have, therefore, had to 'bring forth children . . . in sorrow', in the words of the Scriptures. Those children have had to be nursed through the first part of the long period of dependence characteristic of human infants. The feminist analysis has located the source of female subordination and male domination in these biological differences between the sexes.

The Marxist analysis, on the other hand, has located the origins of female subordination in 'the development of surplus wealth due to the development of production' (Magas, 1971, p. 84); that is, in the phenomenon of private property. The different forms of male domination and female subjection would, therefore, reflect the different modes of production. This analysis sees the oppression of women arising not from biological differences *in themselves*, but from the acquisition of private property which made possible and necessary the exploitation of those differences. The more central the role of private property became, the more ground women lost. Bourgeois women are the culmination of this process: socially useless, their role is to produce legitimate heirs for their husbands' wealth. Working-class women have made greater strides since they were forced into the factory system. While their entry into production was a crucial step, real liberation can only come, as for men, with the overthrow of capitalism and the abolition of private property. For Marxists, patriarchal ideology appears as an ahistorical abstraction or, at best, part of the superstructure.

The Marxists argue that even if a biological argument can

account for the differences between men and women, it cannot account for, and by this omission tends to underestimate, the staggering differences among women. How can it explain and properly understand the differences between the woman of the aristocracy and the peasant woman, herself often little more than a beast of burden; between the child-like ornament in her Victorian drawing-room and the world-weary prostitute of the next street; between the middle-class college student and the waitress who serves her her third cup of morning coffee?

This is the class question, the crucial dimension for Marxists. Feminists counter that not only does the sexual caste system precede private property, reaching back into the animal kingdom itself, but that it survives its abolition. The sexual caste system shows no more sign of breaking down in socialist countries than in capitalist, unless it is treated, for itself, as a crucial division in society.

This conflict between a Marxist and a feminist analysis has pervaded the literature for a decade. The feminist analysis has been able to account for the differences in life-chances between men and women, but has fallen short of a credible explanation of the differences *among* women. The Marxist analysis has been persuasive in explaining the class differences, but is much less adequate in its explanation of the omnipresence of the status differences *between* men and women.

At this level of inquiry into 'first causes' it has often seemed more like an attempt to deal with the 'eternal verities' than a treatment of a manageable sociological problem. As a result, this study does not approach head-on, as it were, the seemingly unanswerable question: and in the beginning, how did it all happen? Rather it is an attempt to conduct a more historically specific inquiry. The crucial questions become: can both a feminist and a Marxist analysis account for the changes in the role of women during a particular historical period? do such accounts conflict with each other, making a choice inevitable? do they overlap to such an extent that retaining both would be redundant? or, finally, are they complementary; can they, in fact, usefully coexist? These are the questions which will be examined in the last chapter at which time they can be considered in the light of the particular historical study which follows.

1

The Changing Role of
Women in the Seventeenth Century

The seventeenth century has been called 'one of the great watersheds' in modern English history (Clark, 1947, p. ix). The transition from feudalism to capitalism interlocked with the rise of Protestantism to leave no aspect of English life untouched. Yet my decision to consider investigating seventeenth-century England was based initially on a much more limited kind of lead.

It was chosen because of scattered references in various sources to the work of Alice Clark on seventeenth-century England (1919). Her thesis seemed to be that women had played a more important role in the pre-industrial economy than they had subsequently. Any casual student of English history would also have known that it was the century which encompassed both what Hobsbawm has called 'the first complete bourgeois revolution' (1954, p. 63) and the ascendancy of what Weber termed the Protestant ethic (1958). And slowly, as the study proceeded, understanding the rise of capitalism on the one hand, and the development of Protestantism on the other, became central to developing an interpretation of how and why the position of women had changed during the seventeenth century. But saying this skips over an important part of the process which led to its selection.

Apparently Clark had shown that pre-industrial women played a greater part in the economy. This was not an undisputed point of view. Marx had held that, on the contrary, it was the development of technology that had made possible, and even necessary, the introduction of women into the economy (1906, p. 394). Engels went further, calling 'the rule of the wife over her husband, a natural consequence of the factory system' (1958, p. 164).

Why did Clark's interpretation differ from Marx's? Her

conclusion had arisen from a study of the seventeenth century. But – and the importance of this was not immediately evident – this was a hundred years *before* the Industrial Revolution. If the important dimension in understanding the changing position of women in the economy was industrialisation, either because it further limited women, as Clark was interpreted as having said, or because, on the contrary, it made possible women's direct role in the economy, as Marx believed, why was the crucial period for Clark *one hundred years prior to industrialisation*?

A study of seventeenth-century economic history (Tawney, 1912; Hoskins, 1957; Everitt, 1967) along with a careful reading of Clark revealed why she had selected that century, and not the late eighteenth century, as her period. The late sixteenth and early seventeenth centuries have been interpreted by scholars as the decisive moment in the collapse of the feudal economy and the simultaneous process of capitalisation (Dobb, 1947, p. 18). It was this transitional period from feudalism to capitalism that Clark had been studying. The collapse of the feudal economy meant the decline of the domestic and family industry upon which it was based. Clark was only peripherally dealing with the effects of industrialisation on women; her main focus, and what she was explicitly considering, was the effects of the decline of feudalism and the rise of capitalism on the family and, therefore, on women. What then was this study to consider as being most important to understanding the changing position of women: the rise of capitalism (as had Clark) or the development of technology (as had Marx)?

Marx proposed that industrial capitalism was crucial in redefining the role of women. But this was in contrast to the focus of his total analysis, namely, the rise of capitalism. The social relations of production, he insisted, determined how the means of production would be used. Marx's definition of the Civil War and its consequences make this clear (1969, p. 139):

The Revolutions of 1648 and 1789 . . . were not the victory of a definite class of society over the old political order; they were the proclamation of political order for the new European society. The bourgeoisie was victorious in these revolutions; but the victory of the bourgeoisie was at that time the victory of a new order of society, the victory of bourgeois property over feudal property, of nationality over provincialism, of competition over the guild, of partition over primogeniture,

of the owner of the land over the domination of the owner by the land, of enlightenment over superstition, of the family over the family name, of industry over heroic laziness, of civil law over medieval privilege.

Why did Marx, who so clearly saw the rise of capitalism as the key process, focus on industrialisation when he came to study women? Why was he so impressed because industrialisation had freed them to work outside the home? After all, in feudal times men did not primarily work outside the home either. The division between 'working' and 'living' had not yet been made; the workplace and the home were coterminous.

There are two plausible and complementary explanations. First, Marx was comparing working-class women not to peasants but to the bourgeois women – leisured and at home – with whom he was more familiar. Second, his view of women led him to believe that the introduction of machinery had enabled women to participate in the economy because great physical strength was no longer required (1906, p. 431).

In fact, women had been active in all aspects of the feudal economy, including those areas requiring physical strength and endurance. That Marx had shared some of the preconceptions of his age about women, and that this had led him to abandon his overall analysis when considering them, seems reasonable. A 'Marxist' analysis would suggest that, since the society was so completely transformed during the transition from feudalism to capitalism, the position of women would also have changed; that is to say, that capitalisation rather than industrialisation should be the key process on which to focus.

What about a feminist analysis? What would it suggest as the crucial dimension in understanding the changing role of women: the rise of capitalism or the Industrial Revolution? For the feminist, the family is the mediating institution between women and society. It is here that 'the social function and the psychic identity of women as a group is found' (Mitchell, 1971, p. 182). The most familiar theme in the literature has been the effects of early industrialisation on family life. Perhaps, then, this was the most important period not just for the social worker but also for the sociologist? This would be the starting point: the mother forced to neglect her children in order to work inhumanly long hours in the factory.

To the long working hours away from home were added insanitary working and living conditions and very large families. Child neglect was rife and disturbed the public conscience. So did also the fact that many working-class women, used from early childhood to work in factories, had so little experience in the most elementary household duties that they were unable, not only through sheer lack of time and physical exhaustion, but also through absence of training, to turn their living quarters into 'homes' – with the result that many husbands took refuge at the public house or the 'gin-shop'. (Klein, 1963, p. 30)

But with what would this bleak picture be compared? Who was the pre-industrial woman?

The first answer and the easy answer – that she was a peasant – was wrong. The economic historians, beginning with Marx but not ending there, as C. H. George has shown (1971), have pointed out that people did not leave their land to flock to the factories. On the contrary, they had already been evicted or 'freed' from the soil. By the time of the Industrial Revolution there was a virtual army of people totally dependent on wage labour employed in agriculture, manufactories, in their own hovels or in domestic work. A complex system of poor relief and Poor Laws was already in effect to deal with the vast surplus landless population which threatened the tranquillity of the English countryside as well as the burgeoning towns and cities (Hill, 1969c, p. 261). Nor, on the other hand, was the capital to build and run factories accumulated through the feudal economic arrangements; it was amassed during pre-industrial capitalism.

As a result, both the wage-earning family and the bourgeois family were well established long before the Industrial Revolution. The economic basis of this pre-industrial, but post-feudal family was the same as that of the industrial family: it was totally dependent either on the wage labour of individual family members, or on capital. The fundamental changes in the family occur, then, not with industrialisation, but with capitalism. The peasant evicted from the land must turn to wage labour for sole support; the bourgeoisie lived not from the result of its own labour as did its predecessors, the craftsman or trader, but off capital – the surplus value realised through the surplus or unpaid labour of the newly forming wage-earning class (Marx, 1935, p. 45).

The family ceased to be the economic unit of production. It was this process – the decline of family and domestic industry –

which shattered the interdependent relationship between husband and wife, which led to the identification of family life with privacy, home, consumption, domesticity – and with women.

Both a feminist and a Marxist analysis would indicate, then, for different though related reasons, that the transition period from feudalism to capitalism rather than the process of industrialisation was the most crucial. This was so because for the Marxists it had been the most important transformation in the society in a thousand years, for the feminists because the family, that institution which mediates between women and society, had been fundamentally altered as a result of the transition.

The decision to interpret the changing position of women in terms of the transition from feudalism to capitalism was made with Marxist and feminist considerations in mind. Essentially, however, it resulted in a Marxist explanation; that is, it assumed that the mode of production determined the role played by women in society. This proved useful in accounting for the productive role played by women of all feudal estates. It further explained the development in capitalist society of 'two nations' of women, to use Viola Klein's descriptive phrase (1963, p. 28). Women of the labouring class were burdened with toil at home and work; women of the bourgeoisie found themselves atop a pedestal. From this pedestal – bored with their life of idleness and powerlessness – they would eventually press their 'feminist' demands.

This account – the analysis of the transition from feudalism to capitalism – did not lend itself, however, to an interpretation of the changing ideas about women which developed in the same period. Historians agree that feudal women of all classes had been economically productive. The reason seemed clear: the family was a unit of production. Women were partners with their husbands in the economic functions of the family, a situation which gave rise to what Power called a 'rough-and-ready equality' (1965, p. 410).

But this was in conflict with most of the literature written about women in feudal times, the literature of the Catholic Church. Its ideas about women, far from mirroring ideas of equality, concern rather their evilness, their potential threat to men, their general uselessness to men except in procreation. It viewed the family as a third-rate choice for the weak; men and women were urged to enter monasteries and nunneries to avoid cohabiting with each other. To put it another way: at a time when

the family was the economic unit of the society, the best the Catholic Church could find to say about that institution was still Paul's admonition that 'it is better to marry than to burn' (1 Corinthians 7 : 9).

On the other hand, by the end of the seventeenth century women of the rising bourgeoisie were increasingly idle, their leisure first becoming an occasion for ridicule, then a status symbol. Their image at this time, however, had become one of helpfulness, loyalty, domesticity and purity. The Protestant preachers had turned Catholic ideology on its head: women were now the custodians of morality and spirituality; men were tarnished by the dirt and corruption of the world. As the inquiry into religion proceeded, a means of studying changes in patriarchal ideology became clear. For during this period it was the church, more than any other institution, which carried and dispersed the ideas about the nature of men and women, and the appropriate relationship between them. Studying the teachings of the church about women, men and the family gave rise to some interesting questions.

Why did the Protestants harshly attack the Catholic ideas on the evilness, the carnality, the seductive powers of women? Why did they adamantly insist instead upon the image of 'good wife', as helpmate and companion to man in the travails of his life? The answer was first sought by looking at the changing economic system. Were the Protestants' ideas about women reflecting in some way the transition from feudalism to capitalism? It seemed not. For the redefinition of patriarchal ideology by the Protestant preachers was proceeding in the late sixteenth and early seventeenth centuries. At that time they were still decrying the greed and corruption of the emerging capitalist system which, they felt, endangered the existence of religion itself (George, 1971, p. 405). More important, the Protestants, in their redefinition of the relationship between men and women, were referring not to the bourgeois family but to the working partnerships prevalent in the household of the yeomen and craftsmen, that is, to the feudal family.

It seemed reasonable, then, to consider that it developed out of the early Protestant world-view itself: from their doctrines advocating a life in the world, rather than an escape from it, a married rather than a chaste life, a life with woman rather than without her. The Catholic ideas on the evilness of women were not suitable to the gentle life of conjugal bliss that the Protestants

envisioned for themselves. They wanted a life with women. But they were no more prepared to grant women a life of equality with them than were the Fathers of the Church of Rome. With great ingenuity and countless contradictions they proceeded, not to undermine, but to change the *nature* of patriarchal ideology to conform with their developing view of the world.

Addressing themselves to the institution of the family, they invested it with an ideological significance which owed more to the Jews of the Old Testament than the Christians of the New. Within the family they set guidelines for the relationship between husband and wife, and developed appropriate attitudes about sexuality, love, marriage and divorce.

The church was the primary institution for education and propaganda in the feudal and early capitalist world. Its teachings indicate that the ideas that men and women held about themselves, each other and the relationship between them, were not simply reflections of the economic system. Rather these ideas appear, as it were, to have had a life of their own. The churchmen themselves would agree. For on a manifest level they attributed the inferiority of the female sex, at least in part, to her biology. Like the Catholic Church, the Protestants believed that Eve's transgression had only made the yoke of women painful. 'The woman in innocency was to be subject to the man' (George, 1961, p. 277). Her nature suited her for a life of obedience, his for a life of domination.

That there was a relationship between the emergence of capitalism and Protestantism, if not the nature of that relationship, has been taken as axiomatic by all scholars since Marx and Weber. At the end of his book *The Protestant Ethic and the Spirit of Capitalism*, Weber wrote these words (1958, p. 183):

> It is . . . not my aim to substitute for a one-sided materialistic an equally one-sided spiritualistic causal interpretation of culture and of history. Each is equally possible, but each, if it does not serve as the preparation, but as the conclusion of an investigation, accomplishes equally little in the interest of historical truth.

With those words in mind, it was tempting to continue this study a little further in history by looking at the *interconnections* between the changes in the position of women attributable to capitalism and those resulting from Protestantism.

Protestant teachings on women and the family had been patterned on the household of the yeoman or craftsman. Their ideas shifted slowly but steadily in tone and meaning as they were picked up and taken over by succeeding generations whose experience in family life was bourgeois. The home as 'a tent pitch'd in a world not right' (Zaretsky, 1973, p. 102) posed a false dichotomy for Protestants who saw 'little churches' as the foundation of, not a retreat from, the Commonwealth. But the idealisation of the home was one of their more remarkable bequests to posterity. It was an inheritance given substance by the capitalistic division of the world into work and home, public and private. The pale Victorian lady, the ultimate bourgeois woman, was scarcely the Protestants' idea of a worthy helpmate, yet her genesis owed much to their redefinition of womanhood.

The lives of women changed profoundly during the seventeenth century. Their activities, attitudes, behaviour, their place in the order of things, the ideal towards which they were to strive: nothing remained the same. A Marxist and a feminist interpretation each reveal different aspects of those changes. In the next chapter a Marxist interpretation will be used to account for the changes in the role of women during this century. Marx analysed the transition from feudalism to capitalism. He at once railed against, and saw as a necessary historical development, the reducing of 'the family relation to a mere money relation' (1948, p. 123). The effect of this process upon the role of women will comprise the substance of the next chapter.

Following this, in Chapter 3, a feminist interpretation will be used to account for how the ideas about women changed during this period. These ideas, comprising what feminists have described as patriarchal ideology, were undergoing great changes in response to the gradual replacement of Catholicism by Protestantism. How and why Protestants undertook this transformation in patriarchal ideology, and the effects of that on the position of women, will be explored in this chapter.

In the concluding chapter some of the major contemporary literature will be discussed in order to draw out the implications of this historical study for the debate about whether the Marxist and feminist analyses should be seen as rival perspectives or as complementary answers to such questions as: why are men and women treated differently? why do they behave differently? and why have women had to mount a Liberation movement to alter their subordinate place in the scheme of things?

2

The Transition from
Feudalism to Capitalism:
A Marxist Perspective on the
Changing Role of Women

THE FEUDAL FAMILY

In this chapter a Marxist interpretation is presented of how the transition from feudalism to capitalism undermined the basis upon which the feudal family had rested and gave rise to the bourgeois family and the proletarian family. This analysis provides the material for drawing out the consequences for women of the transition from feudalism to capitalism. 'A presupposition of wage labour, and one of the historic preconditions for capital, is free labour . . . [this above all means] the release of the worker from the soil as his natural workshop – hence dissolution of small, free landed property' (Marx, 1973, p. 471).

By 1642 there were an estimated half million workers who had been 'freed' from the soil (Dobb, 1947, p. 230). Their propertylessness was the foundation for the accumulation of property by the growing capitalist class. And the production of both capitalists and wage labourers was, as Marx said, a chief product of capital's realisation process (1973, p. 512). These two emerging classes – one composed of free landless labourers, the other of men of capital – were giving rise to their own forms of the family and new roles for women.

In feudal times the land had been the immediate source of life. Before 1530 the majority of English men and women lived in rural households which were almost economically self-sufficient (Hill, 1969b, p. 20). This situation had to change for the capitalisation of the economy to proceed. Wages or capital had to come to mediate between people and their survival. And, from the latter

decades of the sixteenth century, a growing number of people were becoming totally dependent on wage labour or capital.

The economic basis of the feudal family – that its members jointly made a living from the land – had rested on the unity between capital and labour. The separation of labour from what Marx called 'the objective conditions of its realization – from the means of labour and the material for labour' (1973, p. 471) underlies the decline of the family as an economic unit of production.

What does it mean to say that the feudal family was a unit of production? That its basis was the unity between capital and labour? In what sense is it even possible to analyse the feudal family as if it were a monolithic institution? Is it useful to consider the peasant's hovel, the substantial farmhouse of the yeoman and the enormous village-like manor as sharing common elements which can then be compared to the capitalist family?

The short answer lies in returning to the Marxist formulation about the unity of capital and labour in feudal society. But, in order to understand the implications of this for feudal family structure, the historian must become aware that certain pairs of concepts which are part of her own experience, which she sees as 'natural', in fact represent historical ideas: for example, production-consumption, work-home, work-housework, public-private. These concepts arose with capitalism, with the separation of people from the means of providing for their own livelihood. Each pair of concepts can be seen as a different dimension of the separation of labour and capital. Each casts light on aspects of the differences between feudal and capitalist families.

At the same time, in the separation of production from consumption, work from home, housework from work and public from private, the sex division of labour particular to capitalism developed. Having these categories in mind helped to shape the comparison in this chapter of the feudal family with the capitalist family. The following discussion of each indicates in more detail how the concepts were employed.

Production-Consumption: It is a tired cliché that men make money and women spend it. But behind its implicit sexism lies an important reality about contemporary society: the division between consumption and production. The modern family, even with its enthusiasm for pocket-size vegetable gardens, bread

making or furniture finishing, is, economically speaking, a unit of consumption. (The capitalist family *does* produce labour power, however. See p. 78.) Women, furthermore, in popular mythology, if not in reality, are seen as the prime agents of that consumption, whether modest or conspicuous, and men as the chief producers.

The feudal family was a self-sufficient economic unit (Fussell, 1953, p. 44). It owned the tools which it used to grow food for itself from the land. While most poorer peasant families fell short of the ideal of self-sufficiency, wage labour was, none the less, a supplement to the living that they could eke from the land (Hoskins, 1957, p. 172). The point to be made is that production and consumption were coterminous, inter-related and both embedded in the economy of the household. The richest families of the manor and those squatting on the scrubbiest commons ate most of what they grew and grew most of what they ate, made most of what they used and used most of what they made.

There was a division of labour based on sex which varied from class to class. But men and women co-operated in producing a livelihood for their families. Alice Clark wrote that 'in the seventeenth century the idea is seldom encountered that a man supports his wife; husband and wife were then mutually dependent and together supported their children' (1919, p. 12). The identification of men with production and women with consumption awaited the emergence of capitalism. Even then, at first it only properly fitted the bourgeoisie. For working-class women were swept into the proletariat along with their children.

Work-Home: The great debate about whether women should go 'out' to work would have greatly puzzled the stout citizens of sixteenth-century England. Family life and work life were part of the same round of activity in the same locale. Even to say people worked at home and lived at work is to impose concepts which are irrelevant to a description of feudal life. When the young left their families as servants and apprentices it was, for all practical purposes, to join other families (Laslett, 1965, p. 14).

This was changing at the beginning of the seventeenth century. When people were evicted from the land they were separated from 'the objective conditions for the realization of their labour'; they had to leave 'home' to go to 'work'. Who went to work? In the working class it was men and women; in the bourgeoisie

and, therefore, in popular mythology, only men. Women would remain identified with the home, while men started the slow process towards seeking life-satisfactions from 'work'.

Work-Housework: In the last ten years the women's movement has begun to insist that housework must be recognised as work. Its insistence that the socialisation of housework be a goal has been greeted generally with dismay: a dismay that reflects the belief that domestic labour is 'natural'. Encouraging men and women to share this labour communally was sacrilegious; such action helped to push aside the mystifications about the nature of women which have obscured their role in the economy. It is this belief in the 'naturalness' of the wifely and maternal roles that has helped ward off any analysis of the role of the family in capitalism. Pointing out that the family was the producer of the next generation of workers and the service unit for the present was seen as an attack on the 'cult of true womanhood'.

The feudal family was engaged in providing a livelihood for its members. Domestic labour was embedded in the total productive process (Secombe, 1973, p. 5). There was a sex division of labour. But it did not correspond to 'natural' functions (what women do) and 'real work' (what men do): the feudal woman would not be asked 'do you work or are you a housewife?' (Status, 1970, p. 33). Certain tasks of feudal life can be labelled domestic but this reflects contemporary rather than feudal distinctions. Alice Clark made the distinction, and projected it backwards in time (1919, p. 5):

If women were upon the whole more actively engaged in industrial work during the seventeenth century than they were [subsequently] . . . men were much more occupied with domestic affairs than they are now. Men in all classes gave time and care to the education of their children, and the young unmarried men who generally occupied positions as apprentices and servants were partly employed over domestic work.

What did Clark mean precisely by 'domestic work'? She was obviously referring to the kind of work which we are *now* accustomed to women doing within the home.

Public-Private: One of the surest indicators of a person's wealth in our society is the amount of 'privacy' he is able to purchase.

Two centuries of socialisation have insured that most people see privacy as a basic need coming not far after food and shelter.

Privacy is identified with home, with family life. Marx argued that in capitalist society 'man only feels himself freely active in his animal functions – eating, drinking, procreating, or at most in his dwelling' (1964, p. 111). People now feel that they can only 'be themselves' at home. Privacy has become the compensation for alienation from one's labour. The study of feudal society provides evidence that the need for privacy develops through socialisation. Ariès stated that, 'at that time . . . there were no frontiers between professional and private life; sharing professional life – an anachronistic expression in any case – meant sharing the private life with which it was confused' (1962, p. 366).

When each of these dimensions is analysed separately it becomes clear that men are identified with one of the concepts in each pair, women with the other. Men are the producers who go to work, to do 'real' work in the 'real' world. Women are the consumers who stay at home, performing their 'natural functions' of wiving and mothering. They are the custodians of the private and personal life; their role in the economy is obscured. Alice Clark, gently parodying the biblical phrase, put it this way: 'Thus it came to pass that every womanly function was considered as the private interest of husbands and fathers, bearing no relation to the life of the State, and therefore demanding from the community as a whole no special care or provision' (1919, p. 307).

For with the separation of labour from the objective conditions for its realisation came the concurrent separations – really the same separations looked at in different ways – between production and consumption, work and home, work and domestic chores, public and private.

These concepts are used as a matter of course in any analysis of the capitalist family and the roles of men and women in capitalist society. They were made explicit before attempting to understand the feudal family for a particular reason which Ariès stated so well. 'I can tell the particular nature of a period in the past from the degree to which it fails to resemble our present' (1962, p. 9). By discussing them, the particular aspects of the feudal family which are of interest here – namely, those which differ from the capitalist family – are shown in relief. At the same time this has cleared the way for exploring the differences *among* feudal families of different estates, and for seeing how

the roles of women differed depending on the position of their family in the social structure.

The feudal family was a unit of production. Women, as a result, played acknowledged roles in providing a livelihood for their households.

> In every class of the community the life of the married woman gave her a great deal of scope . . . the home of this period was a very wide sphere; social and economic conditions demanded that a wife should always be ready to perform her husband's duties as well as her own, and that a large range of activities should be carried on inside the home under her direction. (Power, 1965, p. 433)

This manifested itself in very different ways depending on 'the manner born'. This can be graphically demonstrated by looking at three of the many gradations of feudal estates: the peasantry, the crafts and tradespeople, and the nobility.

The peasant family

> True, our system is wasteful, and fruitful of many small disputes. True, a large estate can be managed more economically than a small one. True, pasture-farming yields higher profits than tillage. Nevertheless, master steward, our wasteful husbandry feels many households where your economical methods would feed few. In our ill-arranged fields and scrubby commons most families hold a share, though it be but a few roods. In our unenclosed village there are few rich but there are few destitute, save when God sends a bad harvest, and we all starve together.

In these eloquent words Tawney (1912, p. 409) captured the difference between the poverty of the peasantry and that of the wage labourers. People were not totally separated from the objective conditions for the realisation of their labour – even if those objective conditions simply meant holding a 'few roods' of land. And in addition to their own holding they had common rights in the village fields, meadows and wastes (Everitt, 1967, p. 403). This joint access was at once a necessity for survival and the location for some aspects of a communal rather than a family

life (Tawney, 1912, p. 404). 'Ploughing was co-operative, as were many other operations, above all harvesting' (Laslett, 1965, p. 12).

If the poorest section of the peasantry was not without some means of livelihood in the form of land, animals or tools, another section, by the sixteenth century, had succeeded through good luck and clever management in becoming significantly better off than the majority (Hoskins, 1957, p. 141). Referred to as the yeomanry, they have often been romanticised as the backbone of the nation, embodying the 'old English tradition' (Notestein, 1954, p. 70).

The poorer peasantry had to supplement their production through wage labour (Hoskins, 1957, p. 147). The yeomanry, however, represented a near perfect unity between capital and labour. A contemporary account stated that they 'lay out seldom any money for any provision, but have it of their own as Beef, Mutton, Veal, Pork, Capons, Hens, wild-fowl, and Fish. They bake their own bread and brew their own drink' (Campbell, 1942, p. 244). Their self-sufficiency made it unlikely that they would be among those who 'starved when God sent a poor harvest'. As Mildred Campbell put it, 'the pinch of hard times was rarely felt at his own table' (1942, p. 251).

Most peasant families were not so fortunate. 'In her one-roomed or two-roomed cottage, dark and smokey' wrote Eileen Power, the peasant woman 'must labour unceasingly' (1965, p. 428). There were basically two ways for poor peasant families to bridge the gap between what they could produce from the land and their survival. First, there was wage labour. For married couples this usually meant that only the husband went out to work and often just at harvest time. Wage scales were very low, reflecting the cherished idea that families were basically self-sufficient. Hoskins reports that in Wigston in the first half of the sixteenth century there were probably only a dozen men who would have been described in contemporary records as 'labourer' out of a total of some seventy households, but some of these would equally well have been called cottagers and as such would enjoy an estate and standard of living equal to that of a small husbandman (1957, p. 147).

Second, there was the common practice of sending those few children who survived infancy to the homes of the better-off to be servants when they were about 10 years old (Chambers, 1972, p. 40). Children could only be kept at home if their families occupied enough land to keep them busy. By sending them away,

their bed and board was ensured at the same time as they ceased
to be an economic burden on the family. These children would
remain there until they married. The children of yeomen were
far less likely to be sent off as servants. Not only could they be
well employed at home, but their parents could not have afforded
to hire others as servants.

The importance attached to the family as a unit which pro-
vided for its members is well illustrated by the severe legal
punishments for producing a bastard. Public whipping and the
stockade accompanied the insistence that the child be supported
by his parents until he could be apprenticed (Ashley, 1963, p. 57).
The usual fate of the bastard – early death – underscores the
social organisation of feudal society: one's survival was contin-
gent upon membership in a family (Laslett, 1965, p. 149). Bastard
children were merely particular cases of the general rule:
husbands and wives were both responsible for the support of their
families. In general, women 'can hardly have been regarded as
mere dependents on their husbands when the clothing for the
whole family was spun by their hands; but . . . in many cases the
mother, in addition to spinning, provided a large proportion of
the food consumed by her family' (Clark, 1919, p. 145).

Husband and wife were responsible for different aspects of the
productive process. This was especially true for the yeoman's
wife. It was 'beneath her station' to 'labour in the fields or . . .
[care] for swine and other livestock' (Campbell, 1942, p. 256).
But, like her less fortunate sisters, the amount of work she did
in the kitchen, garden, poultry yard, dairy and at the loom was
not restricted: witness Mable Mallet's epitaph:

> From my sad cradle to my sable chest
> Poor pilgrime I did finde fewe months of rest.
> (Campbell, 1942, p. 256)

Her life, none the less, was easier than that of peasant women
lower down the scale who would have also been expected to do
fieldwork and care for livestock. Celia Fiennes wrote about hay
harvesting in the West of England where people were 'forced to
support [the hay on the horses' backs with] their hands, so to a
horse they have two people, and the woman leads and supports
them, as well as ye men and goe through thick and thinn'. Even
to her contemporary eyes it looked like inhumanly hard work and
she 'wondered at their Labour in this kind, for the men and

women themselves toiled Like their horses' (Clark, 1919, p. 62).

There is every indication that the activities of the peasant woman of whatever rank were seen as 'work'. Gervase Markham advised that 'she must be . . . generally skilful in the worthy knowledges which do belong to her Vocation' (Hole, 1953, p. 99). Nor was it suggested that she confine her ministrations to her own family. Rather she was counselled to be 'full of good neighbour-hood' (Campbell, 1942, p. 258). The customs surrounding marriage reflect the fact that the family was an economic unit. A man and woman were expected to show some indication that they could be self-sufficient before they left service to marry (Ashley, 1963, p. 54). But the actual selection of a mate reflected the economic circumstances of the family. The poorer peasantry had little to offer their children, and no way of ensuring them a better life than they had had. As a result there was more freedom of choice in marriage for the poor: 'a man of the lowest classes who had little and demanded little might marry as he could or would' (Campbell, 1942, p. 286). But among the yeomen there was more insistence on a profitable, and therefore an arranged, marriage. And while some of their children bolted and married whomsoever they chose, others took their own and their parents interests to heart, as seen in one young man's letter to his betrothed. 'I know my portion, and when yours is put to it wee shall live the better' (Campbell, 1942, p. 286).

The interdependence of husband and wife and their mutual responsibility for their children combined to make marriage a necessary and 'honourable' estate for men and women of all ranks of the peasantry. 'To thrive the yeoman must wive' wrote Thomas Tusser with better sense than poetry (Notestein, 1954, p. 74). And he usually did, more than once.

By the seventeenth century a distinct section of the peasantry had attained a secure economic position. Their life-conditions conformed closely to the Marxist concept of the unity between labour and capital. The lives of the poorer peasantry were meaner, and their chances of survival more precarious. But even they were not totally separated from the means of making a living.

The roles of husband and wife were integrated with the economy of their households, their labour directed towards filling the physical needs of themselves and their children. As a result, the division of labour between them, while more marked among the yeomanry, did not correspond to production-consumption or work-domestic distinctions.

Husband and wife were economically interdependent; upon them both fell the burden, an awesome one especially for the poorer peasantry, of supporting their children. The key to understanding this interdependence, and the resulting indispensable role played by peasant women in their families' survival, is to realise that in feudal society household and the economy were integrated.

The craftsman's and tradesman's families

Much of what was written about the yeoman's family holds good for the families involved in a craft or trade. Very often these families also had small farms which they worked (Hoskins, 1957, p. 167). The whole family participated in the productive process. Living and working with them were journeymen who themselves expected to become masters. The status distinction between them and their masters was slight since they represented differences in stage-of-life rather than rank (Dobb, 1947, p. 85).

Wives – not women – were an intrinsic part of the productive process. Their right to participate as co-partners was so inviolable that it was assumed that they would continue to run the operation if they were widowed.

> The Weavers, like other craft gilds, regarded a wife as a trade partner having the right to succeed to and carry on the business after her husband's death. Widows, in fact, took over all the rights, privileges and liabilities of their deceased husbands, for example as to the proper number of looms, journeymen and apprentices. (Plummer, 1972, p. 63)

Clearly, in these estates, men and women were engaged in all of the same aspects of the productive process. Young people of both sexes were kept as servants to do the more menial work (Clark, 1919, p. 157).

The productive unit and the household were synonymous. In 1619 the bakers of London justified their application for an increase in the price of bread by listing their legitimate expenses. Among them were food and clothing for apprentices and their children's school fees (Laslett, 1965, p. 1): an illustration both that the family was a productive unit and that the entire household constituted the family.

The noble family
The feudal manor was very close to self-sufficient.

> A large country estate was then an almost self-supporting unit. Its flocks, herds, and pig-styes provided its meat; its fields and gardens supplied the flour for bread made in the bakery, fodder for the horses, hemp and flax for spinning, fruit, vegetables, and all the herbs needed for the medicine chest. Round the manor-house were grouped the farm buildings, the blacksmith's forge where the horses were shod, the slaughter-house, carpenter's shop, laundry, dairy, brewhouse, stables and a variety of outhouses that were used for all sorts of purposes. Fish came to the table from the stew-ponds which had to be kept well-stocked against Lent and other fasts, cider-apples from the orchards, and fuel for the great hearths from the sawpit and woodyard. (Hole, 1953, p. 102)

Apart from some luxuries, usually foreign imports, the people of the manor produced all that they used.

The most likely occupants of the manor besides the nobleman, his wife, their first-born son and any younger children past infancy were a retinue of 'household officers, the gentlemen and gentlewomen in waiting, the ceaseless throng of guests, and dozens or even hundreds of inferior servants' (Stone, 1965, p. 589).

It would be almost true to say that no one had the right to live at the manor except the nobleman himself. People lived there as an adjunct to their place in the world, whether labour, service or marriage. The noblewoman could make it her home only as long as her husband lived. Their eldest son's place was assured only after his father's death. And for a few brief years between infancy and youth, the couple's children lived with them.

Other people lived in the manor when they were in service. People-in-waiting, often of high rank but diminishing fortunes, servants of many gradations, the almost-grown children of other noble families who were there to learn the rules for a gentleman's life, all mingled in the great hall with the never-ending stream of guests. 'To the servants, clerics and clerks who lived there permanently, one must add the constant flow of visitors . . . These visits were not simply friendly or social: they were also professional; but little or no distinction was made between these categories' (Ariès, 1962, p. 393).

There were no rooms set aside for 'business'. People ate, met, talked, slept, made love and made deals all in the same rooms. Living in an environment of open hospitality, a nobleman or his wife was more likely to rub shoulders with his servants than his children, his waiting-people than his parents, his guests than his siblings.

Privacy in the sense of 'being alone' was not an aspect of life in the manor. 'Historians taught us long ago that the King was never left alone. But in fact, until the end of the seventeenth century, nobody was ever left alone. The density of social life made isolation virtually impossible and people who managed to shut themselves up in a room for some time were regarded as exceptional characters' (Ariès, 1962, p. 398). Nor was there any equation of privacy with family life. For while it would romanticise the situation to see all the occupants of the manor as a large productive family, it would be equally distorting to see the noble family as a nuclear unit surrounded by its many servants.

To begin with, marriage among the nobility was an explicitly economic arrangement contracted to further family fortunes and to produce a male heir (Stone, 1965, p. 591). There was no idea that such a relationship would be the occasion for psychological intimacy or a pushing away of the world. Such a reaction would have been, at the least, inhospitable. If servants and retainers had no guarantee of fair treatment and security of old age, neither had family members. The continuation of the family name was the central concern; other considerations were subordinate to it. The separation between 'my family' and the rest of the world was not clear-cut. To keep family fortunes intact the first-born son was singled out as heir, for as long as wealth lay with the land, it could not be divided up without diminishing the size of the estate.

They were not without a sense of family obligation. There were jointures for widows, modest bequests for younger sons, dowries for daughters. But a couple's children mingled with their father's illegitimate children (producing a bastard being a crime only for the lower orders), and with the servants who were often no older than themselves. They were sent out as infants for wet nursing and, when they were older, were sent to other noble families for training in proper deportment. The household can be seen as constantly shifting, with outsiders moving in, insiders moving out.

Many people had a claim on the attention and hospitality of the lord and lady. That these obligations were taken seriously is

shown in this rather hilarious incident in the life of the Hobys. A group of young men hunting on the moors requested hospitality for the night. Sir Thomas received them warmly although his wife was ill. They drank, played cards, spilled wine all over the floor and made much noise. When they were requested to be quieter as a courtesy to their sick hostess they replied with insults. The worst of these contravened the whole concept of hospitality; they demanded to know the cost of their food and drink. Sir Thomas had fulfilled all his obligations; the guests none of theirs. But when he brought a suit against them he was criticised for unneighbourliness (Fussell, 1953, p. 28).

The production of those living in the manor would have been insufficient to maintain the living standard of wealthy aristocrats. The patterns of conspicuous consumption and open hospitality of the English nobility were made possible through land ownership which gave the aristocracy the right to extract the fruits of their tenants' surplus labour. This right to exploit their tenants was particularly necessary to maintain a life-style in which many people were not expected to play a direct role in production. For one of the keys to understanding feudal life is the idea of service – there were those who served and those to be served. The distinction was made not only according to rank but also to stage-in-life (Bradley, 1912, p. 131); the children of the nobility were not exempt from this activity (Hole, 1953, p. 119). 'The idea of service had not yet been degraded . . . sons of houses went on performing domestic functions in the seventeenth century which associated them with the servants' world, particularly waiting at table' (Ariès, 1962, p. 396). It would be limiting, therefore, to look at production only in a narrow sense, for from the point of view of feudal values and expectations, a worthy and indispensable role was performed by those in service.

The role of the nobleman himself seems to have varied considerably. Lawrence Stone wrote that 'an essential prerequisite for membership of the élite was financial independence, the capacity to live idly without the necessity of undertaking manual, mechanic or even professional tasks' (1965, p. 50). None the less, he added, at the turn of the seventeenth century 'landlords had to run just in order to stay still' (1965, p. 50). Clearly the managing of a viable manor was no mean task.

In this endeavour the role played by the nobleman's wife has often been described. There were virtually no aspects of manor life which she could not supervise, and she participated in many

of the less physically laborious tasks. Eileen Power (1965, p. 422) summarised her role: She was

> obliged not only to be housewife in her own capacity, but amateur soldier and man-of-the-house in her husband's absence, and amateur physician when no skilled doctor could be had. She was also obliged to be something rather more than an amateur farmer, for the comprehensive duties of a country housewife brought her into close connexion with all sides of the manorial economy.

While most accounts confirm the role noblewomen played in estate management and in general production (Clark, 1919, pp. 15–28; Fussell, 1953, p. 738; Stenton, 1957, p. 148; Power, 1965, p. 422), Lawrence Stone took an opposing view in the course of his explanation of the religiosity of women: 'given the idle and frustrated lives these women lived in the man's world of a great country house, it is hardly surprising that they should have turned in desperation to the comforts of religion' (1965, p. 738).

One of the women Stone includes in this description left a diary. Lady Margaret Hoby, unfortunately, gives no indication about her emotional state, frustrated or otherwise. But idle she was not. The editor of her diary speaks of her 'ability to read, write [and] keep accounts . . . her knowledge of household and estate management, of surgery and salves' (1930, p. 5). Yet another seemingly unremarkable day in her life was 29 December 1599. After private prayers and her morning round of the house Lady Margaret breakfasted at the usual hour of eight o'clock. She was 'busie about the house' until ten o'clock that night with time out for meals and a discussion with Mr Rhodes, who appears to have been the resident chaplain at the Hoby manor (1939, p. 92). Certainly it was an easy life compared to those of the peasants on her estate. But still, it must be distinguished from the life of the upper-class Victorian woman. The management of the estate, in fact, seems to have been shared by husband and wife. This was particularly true when the men were away, and the women actually took over their responsibilities. Their competence under these circumstances indicates that there was not a gulf of experience between their more regular tasks and those of their husbands. The activities of the Verney women are particularly well recorded. During the Civil War when their men were away they 'acted for them in their numerous and endless

lawsuits . . . they leased their farms, they found a market for the crops; they kept the money hidden in strong chests concealed in mysterious hiding-places and they wrote long and interesting letters to the absent ones full of business and news' (Hole, 1953, p. 51). So while the noblewoman was married for her dowry, her managerial talents, her bravery, her skills in housewifery could do much to preserve her husband's fortune.

The feudal manor was a unit of production. It was the visible sign as well as the actual source of a family's wealth and power. Marriage was the explicitly economic arrangement whereby the integrity of that estate was maintained. A woman was married off by her father, to her husband, for the aggrandisement of her father-in-law's estate, and in order to relieve her own father of the burden of her upkeep. And the ways were many, and seldom subtle, to force the hand of an unwilling young woman (Ashley, 1963, p. 301). If the match were economically successful and the estate thrived, only her first-born son stood to benefit. Even she herself could be turned out, though not without an income, upon the death of her husband.

While husband and wife were rarely alone together, they co-operated in the management of their estate, in maintaining the good health and conduct of their many dependants and in receiving their endless succession of guests. Thus it was that 'at the beginning of the seventeenth century it was usual for women of the aristocracy to be very busy with affairs – affairs which concerned their household, their estates and even the Government' (Clark, 1919, p. 14).

What then happened to the families of these three estates as the capitalisation of the economy proceeded? What was the nature of the bourgeois family and the proletarian family which emerged from these feudal family structures?

THE TRANSITION TO CAPITALISM

The bourgeoisie, wherever it has got the upper hand has put an end to all feudal, patriarchal, idyllic relations. It has pitilessly torn asunder the motley feudal ties that bound man to his 'natural superiors' and has left remaining no other nexus between man and man . . . than callous cash payment . . . The bourgeoisie has torn away from the family its sentimental veil, and has reduced the family relation to a mere money relation. (Marx, 1948, pp. 122–3)

The feudal family of all estates had rested on its access to the means and material for the realisation of its labour. The high standard of living of the noble family was additionally, and importantly, due to its right to extract the surplus value produced by the peasant population. As an institution, the feudal family encompassed almost the totality of most people's lives. Both men and women were integrated in the economy of the household, and were dependent on their own and each other's labour for their livelihood. But this integration of men and women within the household had been synonymous with the social relations of feudalism. And the 'tearing asunder' of those relations meant the separation of labour and capital, production and consumption, work and home, work and domesticity and public and private lives. What were the processes which began to disturb 'the feudal, patriarchal, idyllic relations' between noble and peasant?

A cyclical movement was developing between the increase in capital accumulation and the growth in the landless population. The first was possible in part because of the rising food prices resulting from the expanding population of towns and cities (Hill, 1969b, p. 62). But in turn the population of the towns was being drawn from the growing population of landless people seeking to sell their labour. Peasants were being evicted from the land through enclosure laws and through the conversion of the land from tillage to pasture (Hoskins, 1957, p. 178; Everitt, 1967, p. 406; James, 1967, p. 241). The abolition of feudal tenures in 1646 removed the final brakes on this process. Although three-fifths of the cultivated land was still unenclosed in 1642 a rural proletariat of some half million was being caught between the rising prices and the punitive wage structure (Hill, 1969b, p. 147). (Punitive is here meant very precisely. Both Clark and Hill argue that the object of low wages was to eliminate wage labourers as a class. Those who implemented the wage structure might also be capitalists who therefore depended on the availability of such labour. Their fears about the social consequences of a wage-labouring class on the one hand, and their need for it on the other, created this contradiction (Clark, 1919, p. 90; Hill, 1964, p. 63).

Feudal society was crumbling and the feudal household of all estates shared in that fate.

The proletarian family

At Leeds in Kent, when it was rumoured in 1608 that the tenants' leases would not be renewed, it 'went so near . . . the heart' of one 'poor and simple man, as he lived but few days after, leaving behind him a poor wife lying and three small children having no other dwelling, nor means but the alms of parish to go on'. (Everitt, 1967, p. 455)

Perhaps the poor wife was then moved to lament – 'That is the trouble with men, you can never count on them'. For when peasant families were evicted from the land, marriage ceased to be mutually beneficial to husband and wife. The days of inter-dependence were numbered.

The economic basis of the peasant family had been its land and its access to common lands. The enclosure laws, coupled with the eviction of tenants from their holdings, separated the people from the objective conditions for the realisation of their labour. A class of landless people, totally dependent on selling their labour power, began to grow quickly.

This emerging proletariat was also swelled from the ranks of craftsmen and tradesmen, many of whom were losing their independence. Their self-sufficiency was being eroded in two complementary ways. On the one hand, merchants were setting up craftsmen in the countryside – the so-called putting out system (Marx, 1973, p. 510; Dobb, 1947, p. 231). Their position differed little from wage labourers. They were controlled by the merchants and, at the same time, they provided competition to the existing independent producers who were then gradually taken over by their suppliers.

A new family structure was in the making, and with it the alteration of the life-conditions under which the majority of women had lived. The landless poor were forced to rely entirely on selling their labour power in order to buy what they needed. And if they did not sell their labour, they theoretically did not eat. Willingness and ability to labour were no longer sufficient to ensure survival. Even success in selling their labour was not enough, for wages had been fixed for an age in which they were only a supplement to the living a family eked from the land. When other sources of sustenance were taken away, wages did indeed prove grossly insufficient. 'One fact alone is almost sufficient to prove the inadequacy of a labourer's wage for the main-tenance of his family. His money wages seldom exceeded the

estimated cost of his own meat and drink as supplied by the farmer' (Clark, 1919, p. 118).

He clearly could not afford to support his family; he was, none the less, held responsible. The results of these changes for women were devastating and far-reaching.

The consequences for women. The peasant woman had laboured long and hard every day. But that she shared with the men of her class. When she was evicted from the land she lost the means to help provide a living for her family. Producing at home had, at least, left her in the same physical location as her children. Nursing a baby, supervising a young child, preparing meals had been part of the general labour.

The meagreness of her husband's wages presented her with a grim choice. She could sell her own labour power for half of what her husband could make. This would further endanger her children's survival through lack of supervision and withdrawal of lactation. Or she could stay at home, if indeed she had such a place, and risk starvation for herself and her children.

The productive unit of husband and wife was thus shattered. Marriage became a liability for men while, at the same time, women's dependence upon it was increasing. Marriage became her food ticket, and an inadequate and shaky one at that. A man's obligation to provide for his wife and children was enshrined in the Poor Laws by capitalist farmers unwilling to pay adequate wages and by landowners unwilling to pay taxes for poor relief. For men marriage became their duty to the state, women their burden to support.

> Single women who were known to be with child by a stranger were promptly and forcibly married, sometimes the bridegroom having to be brought to church in chains. Such pressure was not in the interests of morality but to 'save the parish harmless' since by this means it freed itself from the responsibility for both the mother and the unborn child. (Marshall, 1954, p. 299)

A man's only way out to save his own skin was to desert his family as this excerpt from the Second Humble Address of the poor weavers indicates.

> That the Poor's Rates are doubled and in some places trebled by the multitude of Poor Perishing and Starving Women and

Children being come to the Parishes, while their Husbands and Fathers not able to bear the cries which they could not relieve, are fled into France . . . to seek their Bread. (Clark, 1919, p. 118)

Popular mythology had it that the woman was busy making a home for her husband and children. That seems unlikely. She had neither the material nor the psychological means to do it; indeed, by the time she was a generation or two from the land, she did not have the training or knowledge either. She was part of the private world, yet had no private world of her own.

The starvation and misery described in Quarter Sessions Records were not exceptional calamities, but represent the ordinary life of women in the wage earning class. The lives of men were drab and monotonous . . . [but] the labourer while employed was well fed, for the farmer did not grudge him food, though he did not wish to feed his family. There was seldom want of employment for agricultural labourers, and when their homes sank into the depths of wretchedness and the wife's attractiveness was lost through slow starvation, the men could depart and begin life anew elsewhere. (Clark, 1919, p. 86)

The phenomenon of the deserted wife was, therefore, becoming commonplace. What about women whose husbands stayed? They were becoming 'domestic drudges' for their working husbands 'rather than partners in a family workshop' (Hill, 1969a, p. 264).

The bourgeois family

From the second half of the fifteenth century a growing number of men were accumulating capital through agriculture and trade (George, 1971). In the course of that accumulation they developed a life-style, values and a family system that were appropriate to it. That part of the nobility which survived, and indeed became more affluent, found it convenient to incorporate much of what was new in their own lives (Stone, 1965, p. 671).

The outcome of the Civil War can be seen as the victory of this new class of people, the bourgeoisie. This victory ensured that the State would not interfere with, and would indeed support, its interests. 'From 1688 onwards England was, for the propertied class, an exceptionally free society by contemporary European standards' (Hill, 1969b, p. 144).

The family of the bourgeois lived off his capital which he accumulated through his exploitation of workers. This state of affairs had developed in different ways. The successful craftsman started to hire others to work for him. When his workshop grew larger he removed it from his home. Its growth had indicated that he no longer required his wife's labour; its separation from the home removed any likelihood of her participation (Clark, 1919, p. 235). The yeoman, who became a particularly successful farmer, sometimes hired a 'woman servant of the best sort' so that his wife 'doth not take the pains and charge upon her' (Campbell, 1942, p. 213). The result was a household and a family life very different from those of the feudal estates.

The growing affluence of the bourgeoisie was providing them with the means to build larger, more comfortable houses (Hoskins, 1953, p. 44). They were built as specifically private dwellings for three inter-related reasons. First, these homes were only places in which to live; they were no longer places for production as well. Second, they were designed to keep out a world which was now teeming with undesirables. The unemployed, the landless, soon became the beggar, the vagrant and the criminal. Servants once classed as faithful, trusty and child-like were now defined as part of the threatening outside world (Walzer, 1965, p. 189). Third, they were built as private dwellings to match the redefinition of the family as members of a close, intimate group apart from the world. In the course of these developments, a new role emerged for women which was to set the pattern for women of their class for three hundred years.

The consequences for women. When the home no longer included production, and servants were still easily come by, idleness became the new status symbol for women. But at first it had not been widely enough adopted to escape criticism: men used to 'court and choose wives . . . for their modesty, frugality, keeping at home, good housewifery and other economical virtues then in reputation' lamented John Evelyn (Phillips, 1926, p. 70). Samuel Pepys also found numerous occasions to complain of his wife's desire for money and her costly extravagances. That these were more apparent than real is revealed by the cost of each of their wardrobes for one quarter – £55 for his, £12 for hers. As one editor commented, 'He evidently regretted the £12 much more that he did the £55' (Phillips, 1926, p. 83).

Bourgeois women can be seen as parasites, living a life of ease

and luxury – 'the parasitic life of its women has been in fact one
of the chief characteristics of the parvenu class' (Clark, 1919,
p. 296). The Town Ladies Catechism published at the turn of the
seventeenth century satirises their life.

'How do you employ your time now?'
'I lie in Bed till Noon, dress all the Afternoon, Dine in the
Evening, and play at Cards till Midnight.'
'How do you spend the Sabbath?'
'In Chit-Chat.'
'What do you talk of?'
'New Fashions and New Plays.'
'Pray, Madam, what Books do you read?'
'I read lewd Plays and winning Romances.'
'Who is it you love?'
'Myself.'
'What! Nobody else?'
'My Page, my Monkey, and my Lap Dog.'
(Phillips, 1926, p. 102)

On the other hand, can it be said that this life of uselessness
was 'chosen'? Mary Astell, writing *Reflections upon Marriage*
(1730), thought not. 'What poor Woman is ever taught that she
should have a higher Design than to get her a Husband?' It was
in her husband's interest that she was kept at home and unoccu-
pied. He wants a wife,

an upper Servant, one whose Interest it will be not to wrong
him, and in whom therefore he can put greater Confidence
than in any he can hire for Money. One who may breed his
Children, taking all the Care and Trouble of their Education,
to preserve his Name and Family. One whose Beauty, Wit or
good Humour and agreeable Conversation, will entertain him
at Home when he has been contradicted and disappointed
Abroad . . . one whom he can entirely Govern, and conse-
quently may form to his Will and Liking, who must be his for
Life, and therefore cannot quit his Service, let him treat her
how he will. (George, 1973, p. 154)

Astell lit on two of the reasons why the bourgeois woman was
encouraged to play a 'parasitic' and dependent role. First, her
husband wished to will his accumulated wealth to his legitimate

heirs. Unlike the nobility, who bequeathed name and fortune to the eldest son only, the bourgeoisie treated all their children equally. For capital, like land, was infinitely divisible. But, unlike land, it was also infinitely expandable. Since all his children inherited equally, he did not wish to be in doubt about the paternity of any of his children. Second, Astell realised that the family was a haven from the world. But she saw it as a haven only for the husband; for his wife it was, quite simply, a prison.

While capitalism did not cause women to be treated as property, their role in the centre of this narrowly domestic scene did arise directly out of the separation of capital and labour. It is true that in feudal times women's place had also been in the home. But the bourgeois home was only a place to live, not a place to work, only a place for one's family, not the crossroads of the community. As the woman's environment – the home – shrank in size and scope, the man's world was expanding. For him it was a new world of business, politics, the professions, trade, land, the colonies. Elizabeth Janeway expressed it well in *Man's World, Woman's Place* (1971).

The embourgeoisement of the noble family

The turn of the century was a bad time for the English aristocracy. For centuries the feudal land arrangements had served them well. Now they were being challenged by a new breed of landowner who hired only the labourers that he needed, raised rents, evicted tenants who could not pay, worked hard and adopted the more efficient farming methods that were being developed.

These new methods – land drainage and reclamation, the use of fertilisers, hedging and ditching enclosed land – all required capital. Racking rents and evicting tenants required the abandonment of one set of values and its replacement with another (Hill, 1969, p. 66). The investment of capital in new procedures instead of the displaying of wealth in potlatch fashion required a changing life-style.

Certain individuals failed to adapt and thereby faced financial ruin. But the English aristocracy as an important and powerful sector of the population survived. Its survival involved the partial embourgeoisement of its household and family life.

The noblewoman: from feudal to capitalist society. The noblewoman had enjoyed a high standard of living in feudal times.

She was not, however, without obligations to those people whose labour made it possible. She had far more leisure-time than women of other classes. But she put in, by twentieth-century standards, long and busy days.

The capitalisation of the countryside transformed her role. No longer was she foreman of a huge productive estate, or hostess to all who came in their mixed pursuits of business and pleasure. The manor was becoming a private home run by servants who had once mingled with their master and mistress but who were now relegated to the back stairs and servants' quarters. It was shrinking in size as the throngs of servants were pruned down. That, together with the growing availability of consumer goods, reduced the need for a manor's self-sufficiency. The nobility who kept up town houses grew accustomed to purchasing what they needed, and these customs carried over to their country estates. As the productive processes carried on at the manor declined, there was less and less for the noblewoman to do.

At the same time, the men were becoming increasingly involved in business and politics. As the men began to spend more time in London, the wives began to insist that they spend 'the season' there. Two ménages were often set up and there was far less for women to do in London than in the country. The women's sole preoccupation became the social life to which men retreated when their business had been conducted.

The efficient investment of capital began to take priority over the maintenance of the hospitable great house. 'The keeping of open house to all comers gave way to the invitation to personal friends' (Stone, 1965, p. 669). Ben Johnson pointed out the rationale for this change.

> That ancient hospitality, of which we hear so much, was in an uncommercial country when men, being idle, were glad to be entertained at rich men's tables. But in a commercial country, a busy country, time becomes precious, and therefore hospitality is not so much valued . . . Promiscuous hospitality is not the way to gain real influence . . . No, Sir, the way to make sure of power and interest is by lending money confidentially to your neighbours at a small interest, or perhaps at no interest at all, and having their bonds in your possession. (Hill, 1969c, p. 265)

But this flagging of hospitality was not only a pragmatic economic decision. It represented a growing need and desire

to keep out the same elements which promoted the privatisation
of the bourgeois family: the increasing numbers of landless poor,
the many-headed monster (Hill, 1965). (Most writers about
politics during the century before 1640 agreed that democracy
was a bad thing '. . . "The people" were fickle, unstable, incap-
able of rational thought: the headless multitude, the many-headed
monster' (Hill, 1965).)

At the same time as the world was being kept out of the manor,
the world inside was being segregated into 'us' and 'them', a
replacement for the many slight differentiations which had
characterised feudal society. Servants' quarters were springing
up; families retired into living-rooms and bedrooms where serv-
ants were rung for when needed (Stone, 1965, p. 669). The
children of the nobility stopped mingling with the servants and
bastards; the treatment of servants and children, once so similar,
became sharply differentiated. But while their children were
separated from their former companions, they were not made
equal among themselves as in the bourgeoisie. Among the nobility
the principle of primogeniture was retained (Stone, 1965, p. 671)
for as long as the land was the source of a family's wealth its
integrity had to be maintained.

The decline in the physical size of the manor paralleled its
decline in psychological size. There were fewer people for whom
the noblewoman was responsible, and less responsibility towards
those who remained. Relations between the nobility and its
servants grew more like capitalist-worker relations. The values
of the aristocracy did not change uniformly, but in many ways
the aristocratic woman was becoming 'bourgeois'.

A MARXIST ANALYSIS:
TWO CLASSES; TWO CLASSES OF WOMEN

In feudal society the family was the basic economic unit. Viewed
retrospectively, it represented a unity of labour and capital, an
integration of production and consumption, work and home,
work and domesticity, public and private life. The self-sufficient
feudal family had relied on the labour and direction of husband
and wife as co-partners in a serious endeavour: family surival.
For peasant families, for families in craft and trade, this meant
actual physical survival. For noble families it meant perpetuation
of the family name, honour and reputation.

Women played an important role in production and manage-
ment, resulting in a 'certain rough-and-ready equality' (Power,

1965, p. 410) between them and their husbands. 'It is not too fanciful,' suggested Viola Klein, 'to deduce that the knowledge of their equal "worth" produced in women a degree of self-esteem which eluded subsequent generations' (1963, p. 27). In any case, husband and wife were dependent upon each other, and their children upon them both.

The growing penetration of capital into the economy undermined the basis of that family, destroying the unity of capital and labour within it. Peasants evicted from the land became solely dependent upon selling their labour power. As a result, the women could no longer combine in their general labour the bearing, suckling and rearing of children. Without land they were bereft of ways to contribute to their family's livelihood. Who would care for their children if they went 'out to work'? And if that problem could be met, their wages did not cover their own upkeep, let alone their children's.

Their dependence upon their husbands increased. Wives became financial liabilities to poor labouring men, threats to their survival. For the state, having made husbands responsible for the upkeep of their wives and children, then passed maximum wage laws which made the execution of those responsibilities impossible.

In an age when the numbers of destitute poor were rapidly increasing (Hill, 1969c, p. 254), women were over-represented (Clark, 1919, p. 92). Their pauperisation led to starvation, harassment by officials and death while giving birth under hedges and in ditches (Marshall, 1954, p. 298). For centuries their place, however mean and precarious, had been as necessary members of a family. This family had been undermined as an institution because it was no longer a help, but a hindrance to male survival. The desperate situation of many women at the end of the seventeenth century was the result. There was no place, no physical shelter, for them to go with their children. At the same time, many other women began to set the pattern for the role women would play during industrialisation. They sold their labour for pitifully low wages, adding overwork and fatigue to their general destitution.

An affluent bourgeoisie dependent upon capital – that is, the surplus value produced by the landless – was emerging from the better-off yeoman, craftsmen and tradesmen. It was in the course of this separation between labour and capital, production and consumption, work and home, work and housework, public and

private that bourgeois women acquired the particular identity which set the pattern first for noblewomen, and much later, for working women. The spheres of consumption, home, domesticity and privacy became their 'natural' habitat.

Men were making a new world apart from the home: a world of business, politics, investment,' law, a new capitalist and imperialist world. Sheila Rowbotham put it this way: 'The most crucial factor in deciding the peculiar helplessness of women was the exclusion of the privileged from production. As bourgeois man justified himself through his work, asserting his own industry and usefulness against the idea of aristocratic leisure, his woman's life was becoming increasingly useless' (1972, p. 29).

Even Mary Astell and Lady Mary Wortley Montagu, both proponents of female education, would not have espoused her 'justifying' herself through her work.

Mary Astell: 'They [men] may busy their Heads with Affairs of State, and spend their Time and Strength in recommending themselves to an uncertain Master, or a more giddy Multitude, our only endeavour shall be to be absolute monarchs in our own Bosoms' (Astell, 1701, p. 159).

Lady Mary: 'I do not complain of men for having engrossed the government. In excluding us from all degree of power they preserve us from many fatigues, many dangers and perhaps many crimes' (Phillips, 1926, p. 184).

Like the advocates of female education a century later, they failed to see any connection between education and work. That women's lives need not, and indeed should not, be productive was an unquestioned axiom by the beginning of the eighteenth century.

In this chapter it has been shown that women of all feudal estates made important contributions to their families' livelihood. The transition from feudalism to capitalism removed economic production from the household. Women of the rapidly growing proletariat were left dependent on husbands who had no adequate means to support them. Marriage for working people became a threatened institution: men had little to gain from it and much to lose, while women needed a husband more than ever.

The home for the women of the newly emerging bourgeoisie was shrinking to the Doll's House. The women were supported in style, but they were paying a price. Increasingly, they were considered good for very little. By the end of the seventeenth century two clear classes of women were emerging: one destitute, one privileged; one overworked, and the other idle.

The Marxist analysis gives us pause: the lives of women clearly depend so heavily on their social class. What can be left for a feminist analysis? The questions raised in the next chapter – questions about the nature of patriarchal ideology as it was propagated by the Catholic Church and how it was altered through the Protestant Reformation – are of a very different order. They are the feminist questions, and they too are compelling.

3

The Transition from Catholicism to Protestantism, a Transformation in Patriarchal Ideology: A Feminist Perspective on the Changing Role of Women

CATHOLICISM, WOMEN AND THE FAMILY

A feminist analysis of patriarchal ideology raises the questions which reveal the social differences between men and women, differences which are underwritten by the biological inequalities between the sexes. None the less, while nature guaranteed these inequalities, the ways in which they have been manifested and the variations in form and content which have been developed provoke solemn testimony to the creativity and flexibility of the human race. In fact, studying these differences, the differences between societies in their ideas about men, women, the proper relationship between them, the family, love and sexuality has raised voyeurism from a vice viewed with contempt to the legitimate discipline now known as anthropology.

In this chapter a particular example of a radical redefinition of patriarchal ideology is explored; the vehicle for this change was the Protestant Reformation. During this Reformation the basic ideas about men, women and marriage that had been propagated by the Catholic Church were thoughtfully and consciously reshaped by the Protestant preachers. Our particular concern is with the implications of that transformation for the position of women.

In the woman wantonly adorned to capture souls, the garland upon her head is as a single code or firebrand of Hell to kindle men with that fire; so too the horns of another, so the bare

neck, so the brooch upon the breast, so with all the curious finery of the whole of their body. What else does it seem or could be said of it save that each is a spark breathing out hell-fire, which this wretched incendiary of the Devil breathes so effectually . . . that, in a single day by her dancing or her perambulation through the town, she inflames with the fire of lust – it may be – twenty of those who behold her, damning the souls whom God has created and redeemed at such a cost for their salvation. For this very purpose the Devil thus adorns these females, sending them forth through the town as his apostles, replete with every iniquity, malice, fornication. (Rogers, 1966, pp. 69–70)

Extravagant words. But John Bromyard, a prominent four-teenth-century Dominican, did not depart from the substance of clerical thought throughout the Middle Ages when he penned those lines. The position of the Catholic Church on women had been fashioned from the combined misogyny and ascetism of Paul: women were evil and sex was evil. The object – women – and the activity – sex – were part of the same process. It resulted from and rested upon Paul's famous dictum, 'It is good for a man not to touch a woman'.

There was another side to the Catholic teachings about women. The Virgin Mary and the female saints provided an idealised vision of woman: chaste, virginal, loving and other-worldly. While this served to accentuate the failings of most women, it also protected people from the terrible demands of the uncom-promising God of the Old Testament. This protection was offered by a woman and it is not without significance that the highest symbolism of the Church included male and female images. But the relationship between them, as befits images, was *spiritual* not carnal. And to this day the Catholic Church has unhesitat-ingly preached the moral superiority of the celibate life. Normal married life until recently was clearly portrayed as a third-rate choice for the weak while an unconsummated union, recom-mended by Erasmus (Frye, 1955, p. 148), was second-best.

The Catholic Church was supreme in the feudal world, the sole moral authority, the only educational institution. Its views on the nature of women went almost unchallenged. It was the articulate bearer, the enormously influential proselytiser of patriarchal ideology. Given the Church's views on sexuality and women it appears paradoxical that it coexisted with courtly love,

that it permitted men and women with money and power great freedom to enter and leave marriage (Stone, 1965, p. 655), that it had so little to say about the proper conduct of conjugal and family life. There is the cynic's explanation: that the Church was concerned with making and keeping the peace with the rich and powerful, that it has always shown amazing facility to adjust to social conditions. That may be.

But there is a twofold explanation which is logically consistent with the Church's own view of the world. First, its concern was to keep at least some men virtuous and holy, to keep them celibate, unmarried. Since the souls of those who did marry were not as worth saving, defining their proper deportment was not a priority. Second, given the Church's dim view of women it would have been foolish to develop great expectations of them. Little time or energy, therefore, was expended in defining or monitoring their behaviour. If they could not be persuaded to be cloistered virgins, thereby removing themselves as objects of temptation for men (Langdon-Davies, 1927, p. 284), the attitude towards them tended to be one of not particularly benign neglect. The Church, as a result, displayed considerable toleration towards a great range of behaviour that was to come under attack after the Reformation. Child marriages, annulments, the keeping of lovers and mistresses, were all either openly sanctioned, or tacitly condoned, by the Church.

The Protestant Reformation disturbed all that. In the course of interpreting the new religion, preachers reconsidered and altered the Catholic position on all aspects of the family and family life. These changes – in the proper relationship between husband and wife, attitudes towards sexuality, ideas about love, views on marriage and divorce – together transformed the ideas and attitudes about women. The Protestants changed the face of patriarchal ideology. What was it about the Protestant world-view that made it incompatible with Catholic ideas on the family, sexuality and women?

THE PROTESTANT WORLD-VIEW

The Protestant problem with their inherited Catholic views on these 'domestic' matters stemmed from a critical aspect of their theology: namely, the priesthood of all true believers. True belief was a gift from God which could be delivered to a person in any station in life (George, 1961, p. 29).

Three related developments proceeded from this doctrine. First, the Catholic belief in the moral and spiritual superiority of celibacy was attacked. The family man in any calling had as good a chance of being among the elect as any priest. Some said a better chance. 'Celibacy,' ranted William Gouge, a prominent Puritan preacher, 'is a Doctrine contrary to God's word, and a Doctrine that causeth much inward burning and outward pollution, and so maketh their bodies, which should be temples of the holy ghost, to be sties of the devill' (George, 1961, p. 265).

Celibacy was not, of course, banished to the dustbin of English history overnight. While Edward VI permitted bishops to have wives, they subsequently had to be deported, or sometimes worse, under the Catholic Mary. And during the time of the great Protestant Henry VIII, Thomas Cramner, who had been indiscreet enough to marry a German lady, had her carried around in a chest with air holes in it whenever she left the house (Hughey, unpublished PhD thesis, Cornell University). Elizabeth was said to deplore marriage among the clergy, snubbing the wives of bishops (Dickens, 1964, p. 246), and as late as the end of the seventeenth century, the Puritan Baxter echoed St Paul in describing marriage as a 'remedy against lust' (Schucking, 1929, p. 24). The weight of Protestant opinion, none the less, came increasingly to reject celibacy in favour of marriage.

A second result of the doctrine of the priesthood of all true believers was that speaking with God no longer required the mediation of a priest, the intercession of the saints, or the intervention of the Virgin Mary. Third, the Bible was placed in the hands of the lay person. No longer did a person have to await a priest's pleasure for the interpretation of God's word.

Behind these changes lay the more fundamental point: that the whole of one's worldly life had to be lived in a godly fashion. The purpose of Protestantism was 'to enable men to live in this present world so as they may walk with God, even by bringing them from a general and confused thought of Christianitie to a daily and particular care of Godlinesse' (Morgan, 1965, p. 139). Since people passed most of their lives within a family, the proper conduct of family life was no longer only peripherally important. This new interest in the family was emphasised by the growing recognition of the definitive nature of early socialisation and childhood. 'I am forced to judge,' wrote Baxter, 'that most of the children of the godly that are ever renewed, are renewed in their childhood' (Watkins, 1972, p. 53).

The family became the key to fulfilling the awesome goal of the Protestants: that ordinary men and women should make a total commitment to a godly life in both their public and most intimate acts, in their daily utterances and secret thoughts.

But granting each person the right and obligation to confront God directly, without a mediator, through prayer and the Bible, spawned a diversity of religious views which eventually destroyed the institutionalised unity of the church. Is it defensible, therefore, to treat the effects of Protestantism on the family as if it represented one set of doctrines and beliefs? Many scholars and theologians have explored and set out the differences, doctrinal and pragmatic, between Anglicanism and Puritanism. On the other hand, Charles and Katherine George have taken the view that there were no substantive issues dividing Puritans and Anglicans: 'In our effort to find a distinguishing line between "puritan" and Anglican we have found no issue, doctrinal or ecclesiastical, of which we can speak in other than relative terms' (1961, p. 405).

This is a controversial position. But for the aspects of Protestantism relevant to this study, it does seem legitimate to assume that much less divided Puritans and Anglicans than brought them together. This is the position of Schucking, who observed: 'however far apart such people [Baxter the Puritan and Jeremy Taylor the Anglican] were in their dogmatics and in their views on Church government, they were to an astonishing degree in agreement in their ideas concerning practical conduct, in such matters for instance as family duties' (1929, p. xiii).

There is a particular qualification to this position: the far-reaching effects of Protestantism in articulating and propagating a particular kind of family, centred on a particular kind of woman, stemmed from very similar views whether they were enunciated by Anglicans or Puritans. But some of the radical sects of Protestantism had a dramatically different, if short-lived, effect on the family, and for women (Thomas, 1958), though even this exception tended to extend logically (see p. 66) rather than negate the more widely held beliefs on the relationship of each person to God.

The Protestants did not pull their idea of the family out of the proverbial hat. Rather, it was fashioned from two main sources, both dear to the hearts of the preachers: the family partnership which prevailed in the homes of the yeomen and craftsmen, and the great patriarchal families of the Old Testament.

The first source were the families whom Christopher Hill has called 'the industrious middle sort'. The Reformation had occurred at a time when the economic power of the craftsman and yeoman's households, which had been increasing for two centuries, was approaching its zenith. In these families, the father was the undisputed senior partner of an industrious and thriving household with its extensions in the farmstead and workshop (1969c, pp. 435–51), the kind of family from which many Protestant preachers had come. Their fathers had been yeomen and this was often what they were too – at least for six days of the week (Dickens, 1964, p. 245). This kind of family made up the most important part of the preachers' congregations. Noble families had their chaplains (Hill, 1969c, p. 435); the poor probably did not go to church (Notestein, 1954, p. 85).

The second source was the Old Testament. To the Bible-reading Protestant preachers, these families appeared to be contemporary versions of the great patriarchal families that they were rediscovering in the Old Testament. Schucking wrote that 'the English Puritan sought to shape his life by the example of the Bible and particularly by that of the Old Testament. Thanks to this, the great historical achievement of the Jewish people, the creation of its own form of the Patriarchal family, gains an importance for posterity which, till now, has been insufficiently appreciated' (1929, p. 20). The patriarchs of the Old Testament had not only guided their families' economic destiny but had directed their large households through their spiritual crises, holding themselves responsible only to God himself. They had been displaced by the Catholic army of saints and priests whose proper function was to mediate between God and man. Now the Protestants were denying the need for that mediation; man had to stand unprotected before the righteousness and wrath of God. Yet the concern of the Protestant preachers for order and for law prompted a new hierarchy, once again directed by fathers as heads of their households. Their task was to move into the gap created by the dethroned priests and saints and to assume responsibility for the spiritual life and godly behaviour of their families (Hill, 1969c, p. 451).

The kind of family the preachers were viewing and experiencing in Elizabethan England, and the role model provided by the Old Testament patriarchs, resulted, then, in the presentation of the family as a 'little church and a little state' (Haller, 1942, p. 247).

THE 'LITTLE CHURCH'

Family life had to be made equal to its task. And in language varying in tone from sober to something close to enthusiastic abandon, descriptions and prescriptions of the newly sanctified family poured out. 'The family,' said the preacher Gouge,

> is a seminary of the Church and Common-wealth. It is as a Bee-Hive, in which is the stocke, and out of which are sent many swarms of Bees: for in families are all sorts of people bred and brought up; and out of families are they sent into the Church and Common-wealth . . . whence it followeth, that a conscionable performance of domesticall and household duties, tend to the good ordering of Church and Commonwealth . . . Besides, a family is a little Church and a little Common-wealth . . . whereby tryall may be made of such as are fit for any place of authority, or of subjection in Church or Common-wealth. Or rather it is as a schoole wherein the first principles and grounds of government and subjection are learned: whereby men are fitted to greater matters in Church or Common-wealth. (Haller, 1942, pp. 246–7)

The use of the word seminary is not accidental nor the use of 'chastity' and 'virginity' in the next quotation from Rogers. What they wanted to emphasise was the purity of the marriage-bed, the holiness of conjugal love. Here Gouge's sentiments are echoed but in more flamboyant language.

> Marriage is the Preservative of Chastity, the Seminary of the Commonwealth, seed-plot of the Church, pillar (under God) of the world, right-hand of providence, supporter of lawes, states, orders, offices, gifts and services: the glory of peace, the sinewes of warre, the maintenance of policy, the life of the dead, the solace of the living, the ambition of virginity, the foundation of Countries, Cities, Universities, succession of Families, Crownes and Kingdomes; Yea (besides the being of these) its the welbeing of them being made, and whatsoever is excellent in them, or any other thing, the very furniture of heaven (in a kinde) depending thereupon. (Haller, 1942, p. 246)

Such descriptions attest to the new regard in which the family was held. But for the family to be so elevated meant that attitudes

towards sex and women had to be substantially changed. For how were men to live morally impeccable lives copulating with the evil seductresses who populated Catholic treatises? Perhaps the Protestant preachers were not consciously motivated. None the less, they went about the task of rescuing sex and women from what they perceived as the worst slurs of Catholicism. As a result, although 'love and marriage . . . was only one among the many topics of Puritan edification . . . no topic underwent a more interesting or distinguished development' (Haller, 1942, p. 238). Wright confirms this in his massive study from literary sources of the middle class in Elizabethan England (1935, p. 203):

> After the break with the Church of Rome, with its conservative attitude toward all sex relations, new opinions regarding woman, marriage and the home gained favour . . . No longer . . . was virginity held to be the highest good, but a chastity of marriage was glorified by the Protestants. As Puritanism further modified Church beliefs, the insistence upon the sterling virtues of the home became louder.

In their many sermons, books and proclamations on the family, the preachers were not content to rest in the realm of high-flown rhetoric. Rather they dealt quite precisely with all aspects of family life: the relationship between husband and wife, sexuality, love, marriage and divorce, leaving little to the imagination of their congregants. Each of these areas will be discussed in turn.

Central to the running of a stable and godly household was a *proper relationship between husband and wife*. Here the Protestants undertook a delicate balancing act between two contradictory ideas which, if they did not keep each other in check, would destroy the harmony of the household, the stability of the society and the working out of the divine plan. On the one hand, the ideal was projected of close and loving companionship between husband and wife. On the other, there was an insistence upon the subordination of the wife to her husband (Schucking, 1929, pp. 18–55; Haller, 1942; Frye, 1955). The more the first was emphasised, the greater was the fear, seemingly well justified, that wives would aspire to equality with their husbands. But a concern with the second to the exclusion of the first would not have invested the family with the emotional content necessary to produce faithful and responsible husbands.

For the Protestants as laid out in the Book of Common Prayer in 1549 there were three reasons why a man needed a wife:

procreation of children, the relief of concupiscence and the mutual society, help and comfort that the one ought to have of the other. This view contrasted with the view of Aquinas (George, 1961, p. 263) who had submitted that in every way except procreation another man would have been a better companion for Adam than a woman. The Protestants for their part dwelt long and lovingly on the mutual comfort husband and wife should be to each other. Some of the ministers' marriage services, notably Gataker's and Baxter's went even further and asserted the primacy of mutual help over procreation (Johnson, 1969, p. 429). Whether the ordering was changed or not, preachers agreed that marriage was a state 'wherein one man and one woman are coupled and knit together in one fleshe and body in the feare and love of God, by the free lovinge, harty, and good consente of them both, to the entent that they two may dwel together, as one fleshe and body of one wyl and mynd in the equal partaking of all such thinges, as god shal send them with thankes gevynge' (Haller, 1942, p. 245).

The forms of this mutual sharing were not, of course, to be left to the discretion of the married couple. Long lists of duties, correct behaviour, proper forms of address were expounded. All had much the same ring because they stemmed from one over-riding perspective: that the man was obliged to provide guidance in all things to his wife, and his wife was bound to obey. These were good Catholic sentiments. Like the Catholic Church, Protestants also turned to Paul most often for his unequivocal statements: 'Wives submit yourselves unto your own husbands for the husband is the head of the wife.' 'Man is the image and glory of God: but the woman is the glory of the man.' They displayed no reluctance to call upon Paul when appropriate, and to overlook him when he made less popular statements such as his infamous 'It is better to marry than to burn'.

While Paul was their chief historical source for statements that stressed female inferiority, they were not at a loss for their own words to emphasise their deep commitment to the principle. From Milton's poetry, 'Hee for God only, shee for God in him', to the more prosaic and threatening language of William Whately, came the same sentiment: '(e)very good woman must suffer her selfe to be convinced in judgement, that she is not her husbands equall. Out of place, out of peace; and woe to those miserable aspiring shoulders, which will not content themselves to take their roome below the head' (Haller, 1942, p. 249).

The preachers were delivering a double message. It was compounded by the one exception to the otherwise unqualified obedience a wife owed her husband. While it was not greatly dwelt upon by Protestant preachers, it was, none the less, in Haller's words, 'the camel head of liberty within the tent of masculine supremacy'. A wife was instructed to disobey her husband if his order conflicted with one from God. That such a dilemma might confront a woman stemmed from the spiritual equality between the sexes. It was believed that God could communicate as easily with women as with men (1942, p. 252). The Bible had been placed in lay hands; it was each person's own source of God's word. But while family Bible readings undoubtedly encouraged devotion to God, as was their intent, they also gave men and women ideas that had not been in the reformers' script (see p. 66).

Second, the redefinition of the family involved a reworking of the clerical views on *sexuality*. There were two aspects to this process: on the one hand, new attitudes towards marital intercourse had to be developed; on the other, the Catholic insistence on the sinfulness of extra-marital sex had to be articulated with new vigour in order that it could be distinguished from the 'pure virginity' of marriage.

Their acceptance of conjugality has led some writers to stress that the Puritans re-established the naturalness of sexual intercourse (Frye, 1955, p. 159), 'est congressus viri et uxoris natura sua res indifferens neque bona neque mala'. A couple should proceed, according to Gouge, 'with good will and delight, willingly, readily and cheerfully'. The Anglican Jeremy Taylor cited 'a Desire of children, or to avoid fornication, or to lighten and ease the cares and sadnesses of household affairs, or to endear each other' (Schucking, 1929, p. 38–9) as sufficient reason for marital intercourse. There are many admonitions to those who might choose a celibate marriage in the mistaken belief that it would be more pleasing to God. This is in contrast to the Erasmian view that the married state should differ little from virginity and was perfected in abstinence (Frye, 1955, p. 155).

Their condemnations of the sin of adultery, on the other hand, have led to the more popular association of Puritans with sexual repression. Sebastian Franch, for example, saw, 'the significance of the Reformation in the fact that now every Christian had to be a monk all his life' (Weber, 1958, p. 121). For as much as the Protestants insisted on the purity of marital sex, their proclamations

on the sin of adultery were stronger than 'anywhere in Christian literature'. Adultery, intoned Andrewes, 'is of all sins most brutish, and maketh us come nearest the condition of beasts' (George, 1961, p. 272). 'The laws of God shoulde be obeyed and fulfylled, whiche commaundeth bothe the adulterer and the adultresse to bee stoned unto deathe,' thundered Becon. These outpourings seem to have been prompted by three considerations. First, there was the fear that the new tone given to marital relations might have some carry-over to sexual relations in general, that the acceptance of marital sex would somehow open the door to rampant promiscuity (George, 1973, p. 166). Second, the Protestants, in contrast to the Catholics, insisted on the sanctity of the family and its stability over time. Adulterous relations were seen as the greatest threat to the stable kind of family life which was indispensable for the good government of the commonwealth.

Their writing about marital sex reveal a third motivation. Between the concepts of virginity, on the one hand, and adultery, on the other, marriage had a difficult time being defined for itself. For if marriage in one breath was praised as 'pure virginity', in the next it was castigated as a potential whorehouse. 'Neither are husbands to turn their wives into whores, or wives their husband into whoremasters, by immoderate, intemperate, or excessive lust' (quoted in 'L'Espérance', unpublished MA thesis, McGill University). Many such cautions and prohibitions accompanied their assurances that the 'marriage bed was undefiled'.

Frye tries to resolve this contradiction in Protestant thought by documenting the Puritans' acceptance and approval of conjugal love. What they disapproved and feared, says Frye, was lust in marriage, that 'immoderate love whose very violence precluded it from maintaining the stability necessary for the marriage relationship'. The Puritans did see lust as a temporary passion akin to 'fire that is kindled in the stubble [and] is soone put out' (Frye, 1955, p. 156) and, therefore, not compatible with the solid marriages for life which they advocated. But this point is crucial for understanding those who see the Puritans as intrinsically linked with sexual repression: the language that they used to describe lust is the same language used by the Catholic Church to describe sex. Is it not difficult, therefore, to avoid the conclusion that it was the Puritans, rather than Masters and Johnson (as Germaine Greer would have it) who 'supplied the blueprint for standard, low-agitation, cool-out, monogamy' (1971, p. 44)?

And they did it precisely by avoiding the specifically erotic aspect of what had been seen by the Catholic Church as the 'disease' of love.

The Catholic Church castigated sexual love. But it more than recognised its potential intensity, and assumed that those outside its exclusive celibate circle would experience what Aquinas called this 'greatest bodily pleasure' (Frye, 1955, p. 152). The Protestants, on the other hand, would have liked to legislate lust out of marital intercourse. Bolton cautions that the marriage-bed, 'ought by no meanes to bee stained . . . with sensual excesses, wanton speeches, foolish dalliance' while Robinson reminds his readers that a man may play 'the adulterer with his own wife . . . by inordinate affection and action (George, 1961, p. 272). The redefinition of sexuality by the Protestant preachers urged the repression of the specifically erotic component of sexual love, a process which was to reach its full flowering 200 years later in the Victorian belief in the asexuality of women (see p. 100).

It is scarcely fair to the Protestants to separate, even for purposes of analysis, their views on sexuality from their attitude to *love*. Schucking argues that the Puritans' greatest cultural achievement was the bringing together of spiritual and sensual love into one unifying experience (1929, p. 37). His value judgement aside, the substantive aspect of his remark is persuasive. For the Catholic Church had seen spiritual love as directed towards God (Langdon-Davies, 1927, p. 284), while the courtly love tradition had absolutely denied the compatibility of love and marriage (p. 266).

The Protestants, in contrast to both these models, welded the roles of wife and mistress into one, and urged that marital love should be patterned upon devotion to God. This love was seen as an obligation, one which they might have preferred to be able to legislate. Unless both of the marriage partners love each other . . . 'with an ardent love [they] cannot but be damned,' warned Whately (Frye, 1955, p. 155).

Not that young men were advised to marry for love, at least certainly not for love alone. Those who did were 'poor green-heads' (Haller, 1942, p. 265), and would live to rue the day. The encouragement to choose a 'fit wife' was as close as most preachers came to making love a precondition rather than the result of marriage. While virtuousness was the first prerequisite in choosing a wife, second in importance was that she be 'fit'. In modern parlance: she should be 'right for him'. 'Therefore a

godly man in our time thanked the Lord that he had not onely given him a godly wife, but a fitte wife: for he sayd not that she was the wisest, nor the holiest, nor the humblest, nor the modestest wife in the world, but the fittest wife for hime' (Haller, 1942, p. 259).

Some showed more inclination to consider the feelings of the young man. Gataker displayed particular sensitivity.

> A Father may finde out a fit wife and thinke such a one a meet match for his sonne, and her Parents may bee also of the same minde with him and yet it may be when they have done all they can they cannot fasten their affections . . . There are secret lincks of affection, that no reason can be rendered of: as there are inbred dislikes, that can neither be resolved or reconciled. (Quoted in 'L'Espérance', unpublished MA thesis, McGill University)

The idea of marrying for love, though hedged with many cautions, was given a foot in the door by the Puritans. Its ascendancy to the chief ideological underpinning for marriage was to await another century.

Discussions about *marriage and divorce* were problematic for the Protestants. Following from the Calvinist dictum that children owed absolute obedience to their parents on pain of death (George, 1961, p. 290), Protestants believed that it was the parents' obligation to choose suitable mates for their children. Their children's duty was to accept the choice. Yet it is possible for Lawrence Stone to have attributed a preponderant part to the Puritan ethic in 'slowly weakening in the late sixteenth and early seventeenth centuries . . . the doctrine of the absolute right of parents over the disposal of their children' (1965, p. 611). How can this apparent contradiction be explained?

The Protestants were very concerned with stable, non-adulterous, life-long marriages. The selection of a suitable spouse was, they knew, fundamental in attaining this goal. This led them to instruct young men on these matters at length. The instruction in itself presumed some freedom of choice. Preachers were beginning cautiously to enunciate the child's right to at least a veto over a marriage partner proposed by his parents (Walzer, 1965, p. 193). At the same time, there was increasing pressure from children for some freedom to choose (Stone, 1965, p. 664). For marrying an appropriate woman had become especially

critical since the Reformation. The Protestants had made getting out of a marriage impossible except on grounds of adultery. While the Catholic Church had not sanctioned divorce it had evolved a considerable range of 'evasions, fictions and loopholes'. These, according to O. R. McGregor, 'had served to make the medieval system tolerable in practice' (1957, p. 10). Powell has gone further: 'so tangled was the casuitry respecting marriage, at the beginning of the sixteenth century, that it might be said that for a sufficient consideration. a canonical flaw might be found in almost any marriage' (1917, p. 11).

The Protestants abolished all these popish remnants: adultery became the only way out of a marriage. The contradiction between this position and their view of marriage as 'a sweete compounde of both religion and nature' (Frye, 1955, p. 154) was put succinctly by John Milton.

> Among Christian writers touching matrimony there be three chief ends thereof agreed on; godly society, next civil, and thirdly that of the marriage-bed. Of these the first in name be the highest and most excellent, no baptized man can deny . . . but he who affirms adultery to be the highest breach, affirms the bed to be the highest of marriage, which is in truth a gross and boorish opinion. (Powell, 1917, p. 94)

But the least concern of the preachers was with internal consistency. The family was a 'seminary of the Church and Commonwealth' (Haller, 1942, p. 247). Upon it depended the preservation of both.

The Protestants had been willing to compromise cautiously on the right of parents to choose their children's marriage partners. The fusion of spiritual and sensual love had made the choice of a wife too important to leave entirely to parental discretion, while the tightening up of the ways to abandon a marriage had made the choice too irrevocable. But there would be no compromise on the grounds for leaving a marriage. A man, agreed the preachers, 'first . . . must choose his love & then he must love his choice: this is the oyle which maketh all things easie' (Haller, 1942, p. 255)!

THE IMPLICATIONS FOR WOMEN:
A WIN, A LOSS OR A DRAW?

The Protestant ideas on the family, the relationship between husband and wife, sexuality, love, marriage and divorce, were carefully spelled out and full of contradictions. They had implications for women that resulted in a new conception about their true nature and a more precise perspective on their proper role.

But contained in the new were the images from Catholicism which had been only half-discarded. That alone would have made the results of Protestantism for women complex and difficult to unravel. The internal contradictions posed by Protestantism itself further confounded that process. On the one hand, Protestantism contributed, however unintentionally, to an improvement in women's position. On the other hand, it led to a more closely defined and limiting role for women.

An improvement in women's position: from natural allies of the devil to godly companions of their husbands
Were women apostles of the devil? Overwhelmingly Protestant preachers insisted that they were not. They rejected the idea that women were evil for two reasons. The first related to their new conception of the family. For the preachers these families (modelled on the households of the yeoman or craftsman) were not only economically self-sufficient, they were also in spiritual terms 'little churches'. This new moral stature of the family had an inevitably elevating influence on the tone in which women were discussed. A spiritual unit like the Protestants' family needed members who were at least theoretically capable of a high standard of morality. Consequently, doctrines emphasising the evilness of women had to be muted.

Second, the redefinition of sexuality – the rejection of celibacy and the elevation of conjugal love – undermined the Catholic position on the evilness of women. Katharine Rogers has pointed out that while there is no necessary relationship between a condemnation of sexuality and hatred of women, the connection is clear. Since 'abhorrence of sex leads to abhorrence of the sexual object . . . guilt feelings about desire are conveniently projected as female lust and seductiveness' (1966, p. 8).

The phenomenon of seeing women as evil did not suddenly cease. Wright observed, 'it is true that there was no diminution of interest in the age-old controversy, in which priests throughout

critical since the Reformation. The Protestants had made getting out of a marriage impossible except on grounds of adultery. While the Catholic Church had not sanctioned divorce it had evolved a considerable range of 'evasions, fictions and loopholes'. These, according to O. R. McGregor, 'had served to make the medieval system tolerable in practice' (1957, p. 10). Powell has gone further: 'so tangled was the casuitry respecting marriage, at the beginning of the sixteenth century, that it might be said that for a sufficient consideration. a canonical flaw might be found in almost any marriage' (1917, p. 11).

The Protestants abolished all these popish remnants: adultery became the only way out of a marriage. The contradiction between this position and their view of marriage as 'a sweete compounde of both religion and nature' (Frye, 1955, p. 154) was put succinctly by John Milton.

> Among Christian writers touching matrimony there be three chief ends thereof agreed on; godly society, next civil, and thirdly that of the marriage-bed. Of these the first in name be the highest and most excellent, no baptized man can deny . . . but he who affirms adultery to be the highest breach, affirms the bed to be the highest of marriage, which is in truth a gross and boorish opinion. (Powell, 1917, p. 94)

But the least concern of the preachers was with internal consistency. The family was a 'seminary of the Church and Commonwealth' (Haller, 1942, p. 247). Upon it depended the preservation of both.

The Protestants had been willing to compromise cautiously on the right of parents to choose their children's marriage partners. The fusion of spiritual and sensual love had made the choice of a wife too important to leave entirely to parental discretion, while the tightening up of the ways to abandon a marriage had made the choice too irrevocable. But there would be no compromise on the grounds for leaving a marriage. A man, agreed the preachers, 'first . . . must choose his love & then he must love his choice: this is the oyle which maketh all things easie' (Haller, 1942, p. 255)!

THE IMPLICATIONS FOR WOMEN:
A WIN, A LOSS OR A DRAW?

The Protestant ideas on the family, the relationship between husband and wife, sexuality, love, marriage and divorce, were carefully spelled out and full of contradictions. They had implications for women that resulted in a new conception about their true nature and a more precise perspective on their proper role.

But contained in the new were the images from Catholicism which had been only half-discarded. That alone would have made the results of Protestantism for women complex and difficult to unravel. The internal contradictions posed by Protestantism itself further confounded that process. On the one hand, Protestantism contributed, however unintentionally, to an improvement in women's position. On the other hand, it led to a more closely defined and limiting role for women.

An improvement in women's position: from natural allies of the devil to godly companions of their husbands

Were women apostles of the devil? Overwhelmingly Protestant preachers insisted that they were not. They rejected the idea that women were evil for two reasons. The first related to their new conception of the family. For the preachers these families (modelled on the households of the yeoman or craftsman) were not only economically self-sufficient, they were also in spiritual terms 'little churches'. This new moral stature of the family had an inevitably elevating influence on the tone in which women were discussed. A spiritual unit like the Protestants' family needed members who were at least theoretically capable of a high standard of morality. Consequently, doctrines emphasising the evilness of women had to be muted.

Second, the redefinition of sexuality – the rejection of celibacy and the elevation of conjugal love – undermined the Catholic position on the evilness of women. Katharine Rogers has pointed out that while there is no necessary relationship between a condemnation of sexuality and hatred of women, the connection is clear. Since 'abhorrence of sex leads to abhorrence of the sexual object . . . guilt feelings about desire are conveniently projected as female lust and seductiveness' (1966, p. 8).

The phenomenon of seeing women as evil did not suddenly cease. Wright observed, 'it is true that there was no diminution of interest in the age-old controversy, in which priests throughout

critical since the Reformation. The Protestants had made getting out of a marriage impossible except on grounds of adultery. While the Catholic Church had not sanctioned divorce it had evolved a considerable range of 'evasions, fictions and loopholes'. These, according to O. R. McGregor, 'had served to make the medieval system tolerable in practice' (1957, p. 10). Powell has gone further: 'so tangled was the casuitry respecting marriage, at the beginning of the sixteenth century, that it might be said that for a sufficient consideration. a canonical flaw might be found in almost any marriage' (1917, p. 11).

The Protestants abolished all these popish remnants: adultery became the only way out of a marriage. The contradiction between this position and their view of marriage as 'a sweete compounde of both religion and nature' (Frye, 1955, p. 154) was put succinctly by John Milton.

> Among Christian writers touching matrimony there be three chief ends thereof agreed on; godly society, next civil, and thirdly that of the marriage-bed. Of these the first in name be the highest and most excellent, no baptized man can deny . . . but he who affirms adultery to be the highest breach, affirms the bed to be the highest of marriage, which is in truth a gross and boorish opinion. (Powell, 1917, p. 94)

But the least concern of the preachers was with internal consistency. The family was a 'seminary of the Church and Commonwealth' (Haller, 1942, p. 247). Upon it depended the preservation of both.

The Protestants had been willing to compromise cautiously on the right of parents to choose their children's marriage partners. The fusion of spiritual and sensual love had made the choice of a wife too important to leave entirely to parental discretion, while the tightening up of the ways to abandon a marriage had made the choice too irrevocable. But there would be no compromise on the grounds for leaving a marriage. A man, agreed the preachers, 'first . . . must choose his love & then he must love his choice: this is the oyle which maketh all things easie' (Haller, 1942, p. 255)!

THE IMPLICATIONS FOR WOMEN:
A WIN, A LOSS OR A DRAW?

The Protestant ideas on the family, the relationship between husband and wife, sexuality, love, marriage and divorce, were carefully spelled out and full of contradictions. They had implications for women that resulted in a new conception about their true nature and a more precise perspective on their proper role.

But contained in the new were the images from Catholicism which had been only half-discarded. That alone would have made the results of Protestantism for women complex and difficult to unravel. The internal contradictions posed by Protestantism itself further confounded that process. On the one hand, Protestantism contributed, however unintentionally, to an improvement in women's position. On the other hand, it led to a more closely defined and limiting role for women.

An improvement in women's position: from natural allies of the devil to godly companions of their husbands
Were women apostles of the devil? Overwhelmingly Protestant preachers insisted that they were not. They rejected the idea that women were evil for two reasons. The first related to their new conception of the family. For the preachers these families (modelled on the households of the yeoman or craftsman) were not only economically self-sufficient, they were also in spiritual terms 'little churches'. This new moral stature of the family had an inevitably elevating influence on the tone in which women were discussed. A spiritual unit like the Protestants' family needed members who were at least theoretically capable of a high standard of morality. Consequently, doctrines emphasising the evilness of women had to be muted.

Second, the redefinition of sexuality – the rejection of celibacy and the elevation of conjugal love – undermined the Catholic position on the evilness of women. Katharine Rogers has pointed out that while there is no necessary relationship between a condemnation of sexuality and hatred of women, the connection is clear. Since 'abhorrence of sex leads to abhorrence of the sexual object . . . guilt feelings about desire are conveniently projected as female lust and seductiveness' (1966, p. 8).

The phenomenon of seeing women as evil did not suddenly cease. Wright observed, 'it is true that there was no diminution of interest in the age-old controversy, in which priests throughout

the Middle Ages had cudgled their brains for terms evil enough to describe the daughters of Eve'. But, he continues, this point of view was being challenged; 'despite the recrudescence of medieval condemnations of the female sex, a new note of respect was creeping into the popular literature, as writers reflecting the trends of middle class opinion arose to defend woman against her traducers' (1935, p. 465).

Unlike most writers, Wright does not attribute this 'new note of respect' for women to the Puritans, who he states reduced the controversy over women to 'coarse invective and ribald satire' (p. 506), but rather to 'burgher writers . . . who were setting up some early landmarks in the literature of women's rights' (p. 465). None the less as early as 1598 the influential Puritan Robert Cleaver severely admonished those who believed in the evilness of women.

> So that a wife is called by God Himselfe, an Helper and not an impediment, or a necessaire evil as some advisedly doe say, as other some say: It is better to burie a wife, then to marrie one. Againe if wee could be without women, we could be without great troubles . . . These and such like sayings, tending to the dispraise of women, some maliciously and indiscreetly doe vomitte out, contrary to the mind of the Holy Ghost. (quoted in 'L'Espérance', unpublished MA thesis, McGill University)

The challenge to the doctrine of the evilness of women had been sounded.

At the same time, the role of woman as companion and helpmate was gaining legitimacy. 'And the Lord God planted a garden eastward in Eden; and there he put the man whom he had formed . . . And the Lord God said, It is not good that the man should be alone; I will make him a help meet for him' (Genesis 2 : 8, 18). The Protestants interpreted this to mean that woman was man's natural soulmate and helper. In the families that they observed and experienced, women were economic co-partners. They simply extended her role as economic helpmate to spiritual and social arenas: 'husbands and wives should be as two sweet friends, bred under one constellation, tempered by an influence from heaven, whereof neither can give any great reason, save that mercy and providence first made them so, and then made their match' (Haller, 1942, p. 269).

As Haller observed, 'the more important the family became to them as an institution, the more important became the role they found themselves assigning to woman in the life of man' (1942, p. 247).

While basic spiritual equality between men and women is a fundamental Christian tenet, the Protestants took special pains to emphasise it. It proceeded logically from the doctrine of the priesthood of all true believers. 'Some will not allow her a soule; but they bee soulelesse men. God in his Image created them, not Him onely, but Him and Her . . . Some will not allow her to be saved; yet the Scripture is plaine; Shee shall be saved by child-bearing' (George, 1961, p. 282).

The concept of spiritual equality, as the mainstream of Protestantism defined it, was an extremely limited one. But it was given practical application in the Civil War sects which flourished during the period of religious toleration permitted during the Interregnum (Thomas, 1958). The sectarians dealt with the practical problem of a believer cohabiting with a non-believer. The sectarian view which advocated separation from the ungodly meant that women were not discouraged from leaving their husbands if those unfortunates were not among the regenerate. Thus Keith Thomas documented that 'from the early 1640s we find evidence of sectary women casting off their old husbands and taking new, allegedly for reasons of conscience' (1958, p. 345).

Presbyterians were, in fact, against religious toleration because they argued that it would threaten the authority of the father (Hill, 1969c, p. 462) – and the stability of the household, they might have added – a fear which proved all too real in the history of the sects at this time. 'I pray you tell me,' demanded Katherine Chidley, 'what authority [the] unbelieving husband hath over the conscience of his believing wife; it is true he hath authority over her in bodily and civil respects, but not to be a lord over her conscience' (Thomas, 1958, p. 349). It is only the tone, not the substance, which differentiates her remarks from the preachers', that a wife's submission should 'extend not itselfe to anything against the Will and Word of God' (George, 1961, p. 284). The Protestant preachers witnessed their own teachings about spiritual equality being used to undermine their central concern, the stability of the family.

The Protestant campaign against adultery was very clearly aimed at men as well as women; it therefore advocated (if it did not bring about) a single standard of sexual behaviour. For 'although a wife's infidelity may cause greater disaster to the family the same sin in the husband is no less iniquitous' (Wright, 1935, p. 223). While the Protestants insisted on marital fidelity for the good of men's souls (George, 1973, p. 166), and for the proper government of the commonwealth of families, their teachings also constituted a major attack on the double standard (Thomas, 1959). While their rejection of the double standard contributed to intensified sexual repression for men it provided at the same time support to women for their right to equality in sexual conduct.

In the seventeenth century sexual equality for women could only have been secured at the price of intensified repression for men. Christopher Hill has pointed out that there could be no sexual freedom for women without effective methods of birth control. Yet one of the sects, the Ranters, did try to base sexual equality on the principle of sexual freedom. Proclaiming the principle of 'free' love for men and women, they tried to combat the sexual guilt of their age (Hill, 1972, p. 257). Winstanley pointed out the implications for women of this route to sexual equality.

> The mother and child begotten in this manner is like to have the worst of it, for the man will be gone and leave them, and regard them no more than other women . . . after he hath had his pleasure. Therefore, you women beware, for this ranting practice is not the restoring but the destroying power of the creation . . . by seeking their own freedom they embondage others (Hill, 1972, p. 257).

The biological differences themselves precluded equality on the basis of sexual freedom in the seventeenth century. Only by restricting the sexual freedom of men could such equality be realised. By doing this, the Protestants enunciated a strong defence of a single standard of sexual morality for men and women (Thomas, 1959, p. 203).

The attitude to love, to the family and to adultery led to pressure from sons that they be permitted to choose their own wives. Women were indirect beneficiaries, as their right to a veto over a proposed marriage – what Stone describes as 'this signifi-

cant advance in the history of the emancipation of women' (1965, p. 597) – was accepted between 1560 and 1640. It was, of course, only the right to reject a suitor. A lay author warned that a virgin should never express herself positively lest she be suspected of 'somewhat too warm desires' (Rogers, 1966, p. 151). We can, none the less, see this as a step in the not yet completed struggle for the right of women to control their own bodies.

Whether in the interests of family harmony, their more elevated conception of women, or some genuinely humanistic sentiment (Siegel, 1950, p. 43), husbands were counselled to be kind and considerate to their wives, to refrain from criticising them publicly and to chastise them with moderation. The right to beat one's wife though still enshrined in the law, was specifically forbidden by the preachers (Wright, 1935, p. 215). Thomas Aquinas had granted men the right to beat their wives provided that they did not kill them (a modest request). All the Protestant preachers forbade corporal punishment although the tone of some of the prohibitions is somewhat suspect. Fuller counselled that even if a husband had a wife 'of a servile nature, such as may be bettered by beating' he must refrain (George, 1961, p. 285).

There is no reason for ecstasy in evaluating the positive effects of Protestantism upon the position of women. None the less, as we have seen, the preachers were responsible for challenging clearly and publicly the entrenched belief in the evilness of women. They insisted rather that women were created to be companions to their husbands with whom they were spiritually equal and from whom they had a right to expect sexual fidelity. Their strictures against wife-beating must have been welcome. Yet they must rest uneasily, knowing that their admonitions have not been heeded even unto our own generation.

The position of women has not moved, as some would have it, in a progressive march throughout history. What appears as an 'improvement', when considered in one way, takes on a very different aspect from another perspective. For patriarchy itself is not challenged, merely shifted. The Protestant 'improvements' had their darker side.

A more closely defined role for women: 'Art thou to make any choise of a wife? Choose thee an housewife' (George, 1961, p. 287) The Protestants urged Elizabethan householders to be the spiritual leaders of their families. While the Catholic Church

had relied on priests to keep its flock from straying, the Protestants insisted that it was the proper duty of fathers and husbands. 'A Family is a naturall and simple Societie of certaine persons, having mutuall relation one to another, under the private government of one' (George, 1961, p. 276). The women acquired, as a result, a live-in spiritual advisor, her husband. Christopher Hill emphasised this point: that one person's authority meant another's submission. 'At the same time that his responsibility for the moral welfare of his household enhanced the dignity of the father of the family, as Milton noted, the dependence of the rest of the family upon him was increased, including of course that of his wife and children. He was their instructor in matters of conduct' (1969c, p. 443).

The spiritual authority of the husband had a necessary corollary: the inferiority of his wife. This inferiority stemmed from two sources. First, the 'nature of women' suited them to a life of submission. Biological analogies were popular in support of this position: men were the head, women the body. 'The man was not created for the woman, but the woman for the man, who is the glory of God, the woman's head, and every way fittest to be chiefe commaunder in the whole Family and household' (George, 1961, p. 277).

Second, her inferiority was inherent in her role. Protestant preachers did allow that a wife might be spiritually greater than her husband. That notwithstanding, she owed him obedience because he was her husband. 'For the evil quality and disposition of his heart and life, doth not deprive a man of that civill honour which God hath given unto him' (George, 1961, p. 279).

All this is not very much different from Catholic teachings. The differences result from the insistence on the priest-like role of the husband, and from the constant reiteration of the theme of wifely submission. The real implications of their proselytisation on female inferiority are more profound than this. For the Protestant teachings began at the very time when women of the upper classes were beginning to receive excellent education, and when women of the bourgeoisie were finding time to emulate them (Hughey, unpublished PhD thesis, Cornell University).

The breakup of the old feudal structures, the weakened moral position of the Catholic Church, the general renaissance in life and letters (Kahin, unpublished PhD thesis, University of Washington) and the influence of humanist thought (Siegel, 1950) were providing an environment for an unprecedented expansion

of female learning and status. The historian William Wotton, looking back on it in 1694, wrote that there were 'no accounts in History of so many truly great Women in any one age, as are to be found between the years 1500 and 1600' (Kahin, 1932, p. 137).

Reflecting this situation, and undoubtedly encouraging it, was the 'popular controversy about women' (Wright, 1935). This exciting century-long dialogue produced gutsy defences of female virtue and learning as well as vitriolic diatribes against them. Women like Mary Tattle-Well and Ioane Hit-Him-Home offered their own most compelling defence. 'If we be weake by Nature, they strive to makes [sic] us more weake by our Nurture. And if in degree of place low, they strive by their policy to keepe us more under . . . lest we should be made to vindicate our owne injuries' (George, 1973, p. 171).

The Protestant teachings on female inferiority have to be seen against this background to appreciate their full significance. The Protestants were not just in dialogue with the Catholic Church but with the whole 'popular controversy' about women. This helps to explain why women seem to have been unreceptive to the message of their inferiority. The preacher Gouge lamented that inferiors 'thinke their burden the heaviest and are loathe to bear it' and of all inferiors women were 'the most backward in yeelding subjection to their husbands' (George, 1973, p. 168).

'No sooner was she a woman, than presently a Wife' (George, 1973, p. 165). Since it was the role of the family which concerned the preachers, it is a literature not on the image of women but the nature of wives which is their legacy. This contrasts with Catholicism. First, that Church had female religious images worthy of the highest devotion from men and women. The Protestant Church banished these and retained only Jesus Christ and his father, the stern demanding God of the Old Testament. Second, the Catholic Church had provided an institutionalised alternative to marriage for women of high birth. Life in a convent could be, at the least, a way out of an anticipated marriage, and, at the most, an opportunity for leadership and decision making (Langdon-Davies, 1927, p. 272). In any case, it was a life in which a woman was the bride of Christ, a role which, depending on the circumstances, might have been more comfortable than as that of bride to a flesh-and-blood husband.

The suppression of convents left only spinsterhood as an alter-

native to marriage: a thought which must have led more than one unwilling young woman to the altar (Stone, 1965, p. 646). Mary Tattle-Well and Ioane Hit-Him-Home had certainly considered a husband no prize: 'if there had been any lawful way for them to have had Children without Husbands, there hath beene, and are, and will bee a numberless number of Women that would or will never be troubled with wedlocke nor the knowledge of man' (George, 1973, p. 172). The clerics saw no other role but wife for women. The harnessing of the Marys and Ioanes of the world to home and husband was their avowed purpose.

And what should she be like, this proper wife, this only semi-mythical creation of the Protestant preachers? First, she had to be godly (Haller, 1942, p. 257). For would not a woman who loved and obeyed God also love and obey her husband in whose image he had been created? Bridget Cromwell received this letter from her famous father shortly after her marriage.

> Dear Heart, press on, let not husband, let not anything cool thy affections after Christ . . . That which is best worthy of love in thy husband is that of the image of Christ he bears. Look on that and love it best, and all the rest for that. (Schucking, 1929, p. 51)

Arise Evans was impressed by the women of his household, who he insisted 'thought upon God at every breath they drew' (Watkins, 1972, p. 55).

Second, she should have 'that forgetfulness of self which causes her to submit to the inevitable with patience and good will' (Schucking, 1929, p. 44). The perils of childbirth in the seventeenth century, if nothing else, made such a quality, combined with godliness, a formidable source of strength. Alice Thorton (1974, p. 48) wrote of the birth of the ninth of her children, only three of whom survived infancy.

> After this comfort of my child I recovered something of my weakness, better recovering my breasts and milk, and giving suck, when he thrived very well and grew strong, being a lovely babe. But, lest I should too much set my heart in the satisfaction of any blessing under heaven, it seemed good to the most infinite wise God to take him from me . . . And, therefore, with a full resignation to His providence, I endeavoured to

submit patiently and willingly to part with my sweet child to
our dear and loving Father.

John Banks admired the same quality in his wife who, 'was never
known to murmur, tho' I was often Concerned, to leave her with
a weak Family' (Clark, 1919, p. 44).

A woman should also have 'that modesty which causes [her]
to behave as though she were quite ignorant of her merits'
(Schucking, 1929, p. 44). This might have been the only character-
istic of Margaret Cavendish, the Duchess of Newcastle, which the
preachers could have applauded. By her own admission she knew
no housewifery and according to Pepys 'all the town-talk is now
a-days of her extravagances' (Phillips, 1926, pp. 62–4). But she
did write, 'it cannot be expected I should write so wisely or
wittily as men, being of the effeminate sex, whose brains nature
has mixed with the coldest and softest elements' (1974, p. 55).

With all this a woman had to be cheerful, amiable and of
equable temper, particularly towards her husband, 'shunning all
violence and rage, passion and humor' (Campbell, 1942, p. 257).
Even if she were matched with a 'crooked, perverse, prophane'
and 'wicked' husband, it was her duty to be 'milde meeke, gentle
[and] obedient' (Haller, 1942, p. 251).

These were the traits which a woman would bring to her call-
ing. A man exercised his calling in commonwealth, church and
home; for the woman it was only in the last of these three.
Everything within the home 'must be frugally and thriftily done
and her children brought up in a Christian manner, and all she
set her hand to, even "spinning, sewing and knitting" done as
to the Lord' (Morgan, 1965, p. 143).

John Banks was fortunate; his wife pleased him greatly in her
calling. 'She was a Careful, Industrious Woman in bringing up
of her Children in good order . . . a Meet-Help and a good
Support to me . . . always ready and willing to fit me with
Necessaries' (Clark, 1919, p. 44). Samuel Pepys, on the other
hand, an admittedly less virtuous man himself, had a wife whose
domestic talents were, to put it kindly, a bit uneven. 'Home to
dinner, and there I took occasion, from the blackness of the
meat as it came out of the pot, to fall out with my wife and my
maid for their sluttery and so left the table' (Phillips, 1926, p. 76).
How many husbands fared as poorly as he did is unknown.
Clearly Elizabeth Pepys had not conformed to the standards of
the Protestant image-makers.

The time-consuming and important task of cataloguing the virtues of a good woman and the duties of a proper wife had been undertaken with a vengeance. 'The clerics had locked women into one role, a role sanctioned, they said, by divine, natural and human law' (George, 1973, p. 166). The image of the proper wife supplanted that of evil woman in religious literature.

As long as marriages were arranged, failure to marry was the fault of one's parents. As freedom to choose and be chosen gained support, not attracting a husband became a reflection on oneself. There was no escaping the anguish and pain of being unchosen: even the last of the English nunneries had already been suppressed. The right to veto a marriage partner, a landmark in personal freedom, had, therefore, a definite underside for women. Her new problem was to attract a mate while appearing passive and uninterested. The lot of the unmarried woman had often been unhappy in feudal times. It would become a predictable misery as love and the freedom to choose one's love became enshrined as the only legitimate basis for marriage, and as marriage became the sole respectable goal for women.

THE FEMINIST ANALYSIS: A PROPER MARRIAGE; A PROPER WIFE

The Catholic Church counselled a celibate life as the most perfect way of loving God. Through such a life the twin evils, women and sexuality, could be resisted.

The Protestants disagreed. They sought a saintly life, not in escape from, but through immersion in, the world. God was beseeched to 'so spiritualize our hearts and affections that we may have heavenly hearts in earthly employments' (Schlatter, 1940, p. 187). Motivated by this world-view, they developed a new and elevated conception of the family. In the course of this transformation they redefined the relationship between husband and wife, and dealt at length with questions of sexuality, love, marriage, and divorce. Through these discussions, and also more directly, they took on the Catholic conception of woman as evil, and found it to be untrue.

In order that man be not forced to face life alone, God had created woman as his helper and companion. Man was to wed her, bed her, love her and keep her till death. Perhaps in that order. For the Protestants were wary about love as a precondition for marriage, even while unaccustomed optimism made them

reasonably certain that if the decision to marry had been wisely taken, love would surely follow.

Loving companionship was to be only one of the dimensions of the relationship, however. The other was the obedience a wife owed her husband, the responsibility to govern that a husband owed his wife. It took many rhetorical manipulations to put just the proper aspect on the relationship. [Marriage was to be a sweet friendship within a power relationship.] 'We would that the man when he loveth should remember his superiority' (Thomas, 1958, p. 334) went a popular manual on the subject. In 1970 Shulamith Firestone could write 'power and love don't make it together' (1970, p. 139). While the Protestant preachers would have disagreed, their recognition that there was a problem is unmistakable. 'Of all degrees wherein there is any difference betwixt person and person,' wrote Gouge, 'there is the least disparity betwixt husband and wife' (Haller, 1942, p. 250).

There was also the least disparity, as it turned out, between virginity and conjugality. The latter was promoted in images reminiscent of the glowing praise extended to chastity in the Church of Rome. It was then contrasted to lust and passion which were described with much the same language Catholicism had reserved for sexual intercourse. While lust was seen as a typical aspect of adulterous relations, it was a sin equally to be avoided in the marriage-bed.

The importance which they attributed to marriage as a stable, life-long relationship led them to give some support, primarily by inference, to the love-match over the arranged marriage. This provided a splendid opportunity for them to expound on the qualities of a good woman. They produced a formidable list with which a young man should arm himself in his search for a suitable wife.

This is the role – the proper wife – that they substituted for that of evil woman. A way out of evilness was no longer offered to the few, as Brides of Christ, but to the majority, as godly helpmates to their husbands. That was a gain in human dignity. But the rules for her behaviour and character were so stringent, that the result should not be overestimated. The Puritans, said Keith Thomas, 'had done something to raise women's status, but not really very much'. What they had done was to redefine the nature of patriarchal ideology to suit their own world-view.

This chapter has been an analysis from a feminist perspective of the changing nature of patriarchy in the seventeenth century.

While the time period was the same as that considered in Chapter 2, the kind of explanation offered was different, as reflected by the different perspective from which the period was approached. How, then, can the historical oppression of women be best understood? Through an analysis of the mode of production or through an analysis of the ideological mode of patriarchy? This question, that is, the implications of this historical study for the Marxist-feminist debate, will be taken up in the next chapter.

4

An Examination of the
Marxist and Feminist Theories

THE DEBATE

This debate is an ideological dispute that arose as part of the histories of Marxism and feminism, histories that at times have merged into one, and at other times have appeared to diverge completely. The immediate task is to sort out whether the debate has produced inevitably conflicting accounts of female subordination, or whether both are necessary, and together draw us closer to a convincing explanation of women's oppression and exploitation.

Reviewing a little of the history of the relationship between Marxism and feminism will help to put the substantive issues in perspective, and in fact explain why there has been a debate. While there have been women throughout history who have found ways to decry their lot, it was Marx and then Engels who offered not only an explanation for the origins of female oppression and an analysis of its history, but also a strategy for its resolution. For them, the position of women in society was a serious question that would be resolved with the advent of communism. But succeeding generations of Marxists, particularly after the death of Lenin and the political demise of Trotsky, did not develop their analysis further or indeed pay it more than lip service (Mitchell, 1971, p. 76).

As a result, Marxist theoreticians and politicians were caught unawares when women in various New Left groups (who in a second-cousin-once-removed type of heredity owed some of their rhetoric, if not their substance, to the writings of Marx) began to renew that thorny issue, the 'woman question'. In Canada, the dawn of the Women's Liberation movement was heralded in 1967 by women in the Student Union for Peace Action, an outgrowth of the Campaign for Nuclear Disarmament. In a paper entitled, 'Sisters, Brothers, Lovers . . . Listen . . . ' they wrote:

Believing as Marx did that social progress can be measured by the social position of the female sex . . . we will trace the history of the role of women in the New Left in Canada and show that this role is determined by the values of the dominant society . . . [we conclude that] . . . until the male chauvinists of the movement understand the concept of liberation in relation to women, the most exploited members of any society, they will be voicing political lies. (Bernstein *et al.*, 1971, pp. 31, 39)

In left-wing groups everywhere the women's protests met with derision, defensiveness and accusations that they were splitting the movement. The burgeoning feminist thought was defined as being not only outside, but hostile to, anti-capitalist, anti-imperialist ideology. It is true that on a theoretical and intellectual level this wholesale disregard of the now emerging Women's Liberation movement was short-lived. The writings of Marx, Engels and Lenin were scoured by the left, and not in vain. The women had hit on something, it seemed; the 'woman question' was brought out, dusted off and exhibited as evidence that Marxism could encompass and contain the women's movement.

But that initial hostile reception by their fellow-travellers, both men and women, had lasted long enough, been intense enough and often crude enough to convince many erstwhile socialists that a Marxist analysis was just another male analysis with no potential for liberating women. For them the class struggle, not the woman question, became the red herring, a ruse to disguise its progenitor, the patriarchal society. The central issue was the caste-like system into which men and women were ascribed at birth.

This was the basis for the radical feminist position. Radical feminists then delved back into time to claim the earlier feminist movement as part of their history, to pay homage to the forgotten women, and to confirm the legitimacy of their struggle. It was in this way, rather through the back door, that nineteenth- and early twentieth-century feminism made its contribution to the women's movement.

For Marxists the analysis of the position of women is often referred to as the 'woman question'; for feminists it is *the* question, the issue, the 'and-in-the-beginning'. Each theory deals with important issues which the other slights. In large part the strengths of each are the weaknesses of the other.

Here I will first summarise the kind of work that has been done in the last few years from a Marxist perspective, and then show two of the main problem areas which arise in the course of the Marxist analysis but are never properly dealt with: biological inequality and sexism. Following this I will outline the feminist account and discuss the problems inherent in it.

The Marxist analysis has extended Engels's analysis of the integral role played by the family in advanced capitalist society. Peggy Morton began by defining the family as 'a unit whose function is the maintenance of and reproduction of labour power, i.e. that the structure of the family is determined by the needs of the economic system, at any given time, for a certain kind of labour power' (1971, p. 53). She pointed out that the fluctuating needs of the economy for labour power, the requirement of a family for a stable income and the need of husband and children for nurturing are in contradiction even while they act to reinforce the family. Woman in her dual role as housewife and worker is the intersecting point between these increasingly contradictory forces.

Following from this, one of the key questions that Marxists have asked and begun to answer is: what is the relationship between wage labour and domestic labour, and, further, should the time spent in domestic labour be included in determining the value of labour power? Secombe has contributed to this analysis by 'tracing the flow of value right through the reproduction cycle of labour power – as wage goods enter one side of the household unit and renewed labour power bound for market comes out the other' (1975, p. 87). Housework is defined as that labour needed to convert commodities purchased by wages on the market place into 'regenerated labour power' (1974, p. 9). As such, Secombe argues that the housewife produces value by contributing to the production of a commodity, namely, labour power. Secombe has thus elaborated Marx's formulation that the value of labour power is not only 'the value of the means of subsistence necessary for the maintenance of the labourer' but also 'must include the means necessary for the labourer's substitutes, i.e., his children' (1906, pp. 190–1).

While Secombe's argument has met with considerable opposition, this stems from not seeing the doubly deceptive aspect of the wage form. Not only do wages appear as a payment for value produced, rather than as the cost of maintaining the worker, but they also conceal the contribution of domestic labour to the

production of that labour power. In response to critics, Secombe also began an analysis of the relationship between the wage labour of women and their domestic labour. He posits that married women are being propelled in greater and greater numbers to the market place, because the wage for their labour power is greater than the value that they can produce through domestic labour. This is a recent occurrence resulting from the increased productivity of domestic labour due to household technology in conjunction with the even greater increase in productivity in the market place (1975, p. 92). Secombe has explained, through the theory of value, what every working mother who is contributing a *second* income knows: economically, it pays to work. This is usually not true for sole-support mothers whose income cannot cover the necessities of life plus the expenses incurred by their working.

This analysis of the role of domestic labour, women's wage labour and the relationship between the two in capitalist society has been an important advance in the Marxist theoretical understanding of the woman question. Also important has been the study of women from the Marxist historical perspective. While the paucity of such work is surprising, given the centrality of the historical method in Marxist theory, Eli Zaretsky's major articles have clearly illustrated its rewards. Gone is the static notion of the family, of personal life and of the role of women. Their development as intrinsic elements in the rise of the capitalist mode of production takes its place (1973a and b). Margaret George's beautiful little study 'From Goodwife to Mistress' also shows what can be achieved through historical analysis (1973). It could serve as a prototype for the sort of work that is needed.

There are two inter-related questions which a Marxist analysis somehow acknowledges without seriously posing, and which have formed the basis of the radical feminist position. First, there is the issue of the unequal role in procreation between men and women. Second, there is the problem of sexism. Is it, as most Marxists would have it, simply a descriptive term for an attitude that needs to be discarded to allow for working-class solidarity? Or is it more profound than that? Is it a convenient 'cover-up' word which masks the need for a real analysis of how men and women see themselves and each other?

Trotsky never asked what biological inequality really meant for a socialist revolution, but he had no doubt that there was an

inherent inequality which really mattered: 'the boldest revolution, like the "all-powerful" British Parliament, cannot convert a woman into a man – or rather, cannot divide equally between them the burden of pregnancy, birth, nursing and the rearing of children' (Trostky, 1970, p. 61). Everyone knows this is true. Whether Trotsky betrayed the revolution, or whether he was a prophet outcast, this is not the point upon which the charges of prophecy or heresy against him were based. Yet, this is the first area, the unequal burden of maternity and paternity, which the Marxist analysis does not tackle, and as a result has had to cultivate a significant blind spot to avoid. Evelyn Reed is the longest-standing continuous contributor to the position that female biology has not been a factor in oppression. To say that biology is destiny, according to Reed, is to reduce humans to the animal level but 'humans are above all social beings who have long since separated themselves from their animal origin' (1972, p. 4). Not only is this an opinion under considerable attack today, but Reed does not even stick to its herself. When it is convenient she treats human beings and animals as if there were no difference. For example, she combats the argument that women could not be hunters because they were 'biologically handicapped by their uteruses' by saying that 'there is no uterus handicap imposing hunting inferiority upon lionesses and tigresses' (1972, p. 14). Reed tries to have it both ways and it is difficult to take her seriously.

Margaret Benston made an important early contribution to the analysis of the role of women's work in capitalist society (1969). But on the question of biology she is less credible. 'How did it come to pass,' write Benston and Davitt 'that from a position of equal biologic necessity and importance, women came to occupy a socially inferior status?' This is an amazing assumption from which to begin. Men and women are needed equally for the admittedly inevitable task of conception, but surely bearing, giving birth to and suckling infants (not to mention forty years of menstrual periods and five years of menopause) give women by far the more important biological role. And if, as they postulate, women's position in society has always been linked to the work they do, then *this* work must be included, certainly in any Marxist sense of the word.

They go on to caution that we must not conclude, as have some feminists, that the oppression of women proceded the more fundamental dividing of society into classes. For while it is true

that mothers had to nurse babies, this was a result of the long period of dependence of human infants; it was, therefore, the biology of infants, not of mothers, that tied them down to this task! the point is surely that the effects of biology must be dealt with, not explained away. When these authors continue by passing off the fact that there was no sure way of controlling births they provide further evidence of their unwillingness to deal with the historical roots of female oppression (Benston, 1975).

Writings in *Marxism Today* on the 'woman question' are replete with such statements as 'women need no longer be subject to the restraint of their biology' (Hunt, 1975) or 'whatever the historical roots of [women's] oppression, the social inferiority of women is increasingly unnatural' (Hunt, 1974). Despite these throwaway lines, it is hard not to conclude that the effect of biological differences on the position of women is an embarrassment to Marxists, that it is more-or-less known information which, like the happenings in a Victorian bedroom, is best left unexplored.

Marlene Dixon's denunciations of feminism and the autonomous women's movement exhibit more than the usual blindness about the difficulties of an unqualified Marxist explanation for the oppression of women. Dixon is clearly torn. Having been a prime target for the left when she first espoused the Women's Liberation movement, she cannot, even now, discount the earlier need for an autonomous women's movement. She cites men and women from the male-dominated left as having been 'the most vocal and visible and disruptive enemies of the women's struggle – constantly hounding and harassing the early organizational meetings'. Her explanation for their behaviour? 'Sexism, a simple mindless rage at "uppity women" who threatened male supremacy' (unpublished paper). Her castigation of the male-dominated left makes as much sense as decrying individual capitalists for not sharing the wealth with their workers. For Dixon 'male chauvinism' is an attitude to be morally condemned; this may be an understandable reation to a situation, but it is surely no substitute for an analysis. Dixon herself provides poignant evidence of the tenaciousness of sexism when she writes,

Today we face an old familiar battle, for the newly emerging communist camp in the USA is busy liquidating the woman question in the class question; advocating individualized struggle between individual man and women in monogamous

relationships as the proletarian way; refusing to provide any analysis of the exploitation of women and denouncing all struggles around sexism as 'bourgeois feminism'. In short, we women must begin again. (unpublished paper)

For Peter Pink writing in *Marxism Today*, male chauvinism in the working class is simply part of capitalism's big sell (1973, p. 285):

we know to our cost that the ideas of the capitalists can so effectively be made the ideas of the proletarians. If women and children are regarded in the British working class family by the male members of that family in much the same way as the capitalists regard the members of their families, it must be said that the ruling class has convinced a large number of members of the working class of the correctness of that view.

He goes on to state breezily that 'in the British working class family, there are no objective grounds on which male domination can be justified'. Justified to whom? one might ask.

The participants in the *New Left Review* debate agree (without debate) 'that sexism within the working class . . . is based ultimately on the solid foundation of the man's control over the wage' (Coulson, 1975, p. 65). The other half of their own argument, namely, that women are increasingly also working for wages, does not seem to disturb their reasoning, nor does the fact that sexism does not disappear in socialist countries. This facile view of sexism is not an accident but proceeds from Secombe's analysis of the role of housework in capitalist society. A housewife's labour, he writes, 'is compelled directly by the demands placed on her by her husband and children . . . which *only* [my emphasis] reflect the material imperative of the family's needs to keep the total household in the best possible condition given the limits of the wage's purchasing power' (1975, p. 88). What about the housewife's self-imposed demands, her need to be a good mother and wife?

Even women who now make an economic contribution to the home retain to a large extent the feeling that it is their work at home which makes them indispensable. Over and over I have heard women describe how they must go on working at home until everything is perfect, even after they have done a full day's employment, and even though their husbands often say, 'Leave it, you've done enough'. (Rowbotham, 1973, p. 80)

Further, why don't husband and children feel similar self-imposed demands? This oversight of Secombe's is compounded when he raises the question of women going out to work. According to Secombe, 'if the additional goods and services bought with a second wage could not significantly reduce domestic labour time, then the alternative of taking an outside job could never exist for married proletarian women' (1975, p. 92). That some of her chores might shift to other household members, and the possible effects of that shift, is not considered. Nor is the possibility that a woman's housekeeping standards might drop, or that she will work more hours a day than before.

But the real problem is not that Secombe did not consider these questions; it is the further omission that his analysis permits. There is no discussion of what happens in a family when the rational or humane solution might be to distribute domestic duties; that is, there is no discussion of the meaning of 'women's work'. It is not, as Secombe seems to imply, that the duties are inherently unshareable. It is that most men do not want to share them, and that the levels of their not wanting to are deeply buried. And it is that women will feel guilty if they do suggest it, or more likely will not even see it as a potential solution.

In the absence of these questions, male privilege and millennia of patriarchy become translated in the *New Left Review* debate into 'sectional interests', interests which need only be suppressed to allow the collective interest of the class to assert itself through 'revolutionary politics' (Coulson, 1975, p. 67).

If Lenin still lived he would be unhappy but not surprised by some of the substantive issues raised by radical feminism. He had been forewarned. 'Clara [Zetkin, a leader of the German socialist and labour movement] . . . I have been told that at the evenings arranged for reading and discussion with working women, sex and marriage problems come first. They are said to be the main objects of interest in your political instruction and education work. I could not believe my ears when I heard that' (Draper, 1972, p. 84). In a sense, his attitude is symptomatic of the failure of Marxist analysis to deal with the position of what Marx once described as the 'fair sex (the ugly ones included)' (Draper, 1972, p. 88).

Unlike the recent Marxist analysis of women which could take off from the earlier works of Marx and Engels, radical feminism as an explanatory theory still awaited a midwife. The earliest work in the late sixties was primarily descriptive, powerful (as

indeed sisterhood seemed to be in those heady days), but none
the less descriptive. What it did was give full weight to the
experience of female oppression.

In 1970, Shulamith Firestone published what is still the most
comprehensive statement of radical feminism, and a brilliant
book, *The Dialectic of Sex*. She began by asserting what feminists
and Marxists had striven so hard to deny: that historically women
have borne the greater burden for the perpetuation of the species
(1970). Simone de Beauvoir had described this situation in con-
vincing detail in *The Second Sex*: 'The enslavement of the female
of the species and the limitations of her various powers are
extremely important facts; the body of a woman is one of the
essential elements in her situation in the world.' Yet she had
opted ultimately for an existential explanation: 'biology is not
enough to give an answer to the question that is before us: why is
the woman the Other?' (1953, p. 33). For Firestone it *was* enough.
Upon this fundamental biological inequality of the sexes had
risen the caste-like system in which men receive ego gratification
and enjoy creature comforts from their domination of women.
Central to the analysis was the family: the crucible for this
intimate but hierarchical relationship. The recent study of the
family owes much to this feminist appraisal. Through this
approach the family was simultaneously rescued from both its
relative neglect by Marxists and the aura of stuffy boredom
inflicted on it by contemporary social scientists.

The biological inequality of man and woman provided the basis
for the institutions (in particular the family) which have
developed to keep women oppressed. That biological inequality
itself became institutionalised and thus protected against the
changes that the development of birth control techniques, includ-
ing abortion, and safer childbirth procedures might have brought
about. In this context the radical feminists analysed love, sexual
intercourse, the vaginal orgasm (what woman who has read *The
Myth of the Vaginal Orgasm* does not owe a debt to Anne Koedt?
(1973)), abortion, rape, courtship, marriage, the sex role system
and sexuality. Additionally, 'since sexism is so basic and per-
vasive an ideology, feminists are continuously extending their
critique into areas hitherto unrecognized as "political" ' (Koedt
et al., 1973, p. vii).

'Love,' wrote Firestone, 'is the pivot of women's oppression
today.' The unequal power relationship between men and women
corrupts love. Men need women for emotional support (behind

every man is a woman), but are unable to reciprocate. 'The question that remains for every normal male, is then, how do I get someone to love me without her demanding an equal commitment in return?' (1970, p. 137). Women need emotional support, too, but are willing to forgo that in order to 'have' a man. Having a man matters economically but, more insidiously, without a man a woman does not experience herself as a person. Firestone, like other radical feminists, made the point that Freud had endlessly repeated: people are essentially bisexual. Men must deny the 'feminine' in them to be real men; women must repress their 'masculinity' in order not to threaten men (Burris, 1973, p. 356). 'But while the male half is termed all culture, men have not forgotten their female "emotional" half: they live it on the sly. As the result of their battle to reject the female in themselves . . . they are unable to take love seriously as a cultural matter' (Firestone, 1970, p. 137). Firestone began a systematic explanation of why this should be so, although it fell short of a comprehensive theory of how women and men are made in social terms.

The extent of female colonisation has been shown in the acceptance by women of male definitions of their sexuality. 'Women have . . . been defined sexually in terms of what pleases men; our own biology has not been properly analyzed' (Koedt, 1973, p. 199). There is a further and more crucial point that Koedt did not draw out. It is that nature conspired to ensure orgasm to males but not to females. While the very act of procreation insists on the male orgasm, conception can take place even without female arousal. Males did not create this situation, as the radical feminists seem to imply, any more than they decreed that women should have the babies. But these two biological truths together form the basis to an alternative to Marxist theory that sex inequality stems from the mode of production. Inherent in the biological differences is an inequality which human society can struggle to overcome but which a theoretical treatment of the situation of women can scarcely ignore.

This is not an excuse for refusing to study how the institutionalisation of that inequality exaggerated and distorted the ways in which those differences have been played out throughout history. We can assume that the woman at the beginning of the sixteenth century experienced her sexuality differently from her counterpart a century after. And later there was the Victorian woman whose mother told her the night before her wedding: 'After you

are married something very unpleasant is bound to happen. But pay no attention to it. I can assure you I never did.' She was the victim of an organised plot whose goal was nothing less than to cut her off from any sexual pleasure nature might have intended.

The point is rather that all these developments had biologically fertile ground on which to work. It is not that the female orgasm is in any sense 'less' than the male orgasm; some would suggest quite the contrary. Rather it is that unlike the male orgasm it is not intimately connected with procreation; it has not been necessary for the survival of the species, and therefore, its fortunes have waxed and waned with the vicissitudes of human society.

For radical feminism, sexism (with its roots in human biology) not capitalism, is the main enemy of women. Again, Firestone (1970, p. 37):

> 'the contemporary radical feminist position . . . sees feminist issues not only as women's first priority, but as central to any larger revolutionary analysis. It refuses to accept the existing leftist analysis not because it is too radical, but because it is not radical enough: it sees the current leftist analysis as outdated and superficial, because this analysis does not relate the structure of the economic class system to its origins in the sexual caste system, the model for all other exploitative systems, and thus the tapeworm that must be eliminated first by any true revolution.

There are two major problems with the solely radical feminist account of female oppression as it is presently stated. First there is the rhetorical question put by Morton – Does Lady Astor Oppress Her Garbageman? In other words, the positing of a simple caste system of males and females obscures the class contradictions among women (1971, p. 49). Marlene Dixon's polemics have thrown these contradictions into stark relief (1972, p. 229):

> The ethic of sisterhood . . . disguises and mystifies the internal class contradictions of the women's movement. Specifically, sisterhood temporarily disguises the fact that all women do not have the same interests, needs, desires: working class women and middle class women, student women and professional women, anglophone and francophone women have more

conflicting interests than could ever be overcome by their common experience based on sex discrimination. The illusions of sisterhood are possible because Women's Liberation is a middle class movement – the voices of poor and working class women are only infrequently heard, and anglophone and francophone voices are heard separately.

Radical feminism brought out a very important truth but, as Mitchell put it, 'it is a general non-specific truth' (1971, p. 90). Filtered through class, race and culture it endures, but in so doing it also separates, as does light reflected through a prism. It is not that most radical feminists do not, in some sense, recognise class. Firestone insists that the achievement of 'full self-determination including economic independence to both women and children would require fundamental changes in our social and economic structure. That is why we must talk about a feminist socialism' (1970, p. 207). The problem is rather that the privileges of class have been sufficient to forestall any demand by feminists in the middle and upper class for socialism. This is clearly not a simple trade-off of submission in exchange for a certain life-style. It is, rather, that an individual raised consciousness can be useful for the privileged woman and less so, even a liability, for the poor woman.

Second, the lack of a particular analysis of the social relations of production led to an idealistic, and, if executed, possibly dangerous solution, namely, test-tube babies. While Firestone allows that under current conditions 'any attempted use of technology to "free" anybody is suspect' (1970, p. 206), she still sees it as a first demand for feminist revolution. Any proper analysis of capitalist relations of production and imperialism and how they would deal with test-tube babies, let alone how a fascism of the right or left would use this power, would surely have made the present state of the biological tyranny of childbirth pale by comparison. There is a further problem with a purely technological solution. Firestone asserts correctly that 'the natural is not necessarily a human value' (1970, p. 10). But she extends this to its perhaps logical but alarming conclusion that 'humanity has begun to outgrow nature'. This resembles the ideology of Western man which began perhaps harmlessly enough when God gave man 'dominion over the fish of the sea, and over the fowl of the air, and over every living thing that moveth upon the earth' (Genesis 1: 28), but has now, with the development of capitalist

technology, reached its most dangerous hour. The opportunity of watching as people wreak havoc with nature will perhaps make feminists more cautious in assuming that radical changes to nature will necessarily bring liberation.

There is a third weakness in radical feminism which exists because the methods of history and psychoanalysis have not been used to extend its theoretical development. The analysis has been couched in an ahistorical framework in terms of both the race and the individual. While biological differences are constant, the institutions which have emerged from them and then turn back to magnify or lessen their effects are not. I hope that the chapter on Protestantism illustrates how the forms of patriarchal ideology do change and can be analysed historically.

The individual history, how a man or woman is made in social terms, how those biological differences are transformed into their social meanings, has also not been analysed. And as Wollheim has put it, 'if it is psychoanalytic theory that is looked to as that from which the necessary supplementation will come, it is hostility and not mere negligence that has first to be surmounted' (1976, p. 61).

The hostility is not hard to find. Kate Millett refers to Freud as 'the strongest individual counterrevolutionary force in the ideology of sexual politics' (1969, p. 241). For Anne Koedt, it was 'Freud's feelings about women's secondary and inferior relationship to men that formed the basis for his theories on female sexuality' (1973, p. 200). Firestone even suggests that clinical Freudianism was imported into the United States to 'stem the flow of feminism' (1970, p. 68). There is good circumstantial evidence for the charges, especially if one looks at the work of Freud's more errant disciples (Marie Bonaparte and her clitoridectomies, God forbid; see Koedt, 1973, p. 201) and at the clinical work of practitioners.

But Juliet Mitchell, whose earlier work called for the study of psychoanalysis, a theory that attempts to explain 'how women become women and men, men' (1971, p. 167) has undertaken to rescue the science of psychoanalysis for the use of revolutionary feminism from both its practitioners and its feminist detractors. On one basic point Freud and the feminists agree: the essential bisexuality of humanity. The aim of psychoanalysis is, therefore, not discordant with that of feminism. 'Psycho-analysis does not try to describe what a woman is – that would be a task it could scarcely perform – but sets about enquiring how she comes into

being, how a woman develops out of a child with a bisexual disposition' (Freud, 1964, p. 116).

Feminists were put off using the tools of psychoanalysis to answer this question; their answers have thus tended to be polemical, shedding more rhetoric than light on the subject. Mitchell has begun to put this right. Her analysis is challenging and exciting. Her restoration of the unconscious to the full place it deserves – for psychoanalysis is the science of the unconscious – helps to explain what people dimly comprehend: that how they feel about being masculine or feminine goes deeper than they care to know. The child becomes what the parent unconsciously wishes it to become; the assurance of those who 'brought their children up in the same way regardless of sex' is shattered. This, of course, is not an excuse for despair: 'the therapeutic task which psychoanalysis sets itself, "to repair all the damages to the patient's memories", can be carried out because even the impressions of infancy "have never really been forgotten" but are "only inaccessible and latent, having become part of the unconscious"' (Reiff, 1961, p. 44).

Along with her insistence on the study of the unconscious, Mitchell's introduction into feminist and Marxist literature of the significance of Freud's other great and related discovery, that of infantile sexuality, is long overdue. Her precise formulations on the making of the female and male in social terms, and the relevance of this to the overthrow of patriarchy, however, raise serious questions. She closely follows Freud's formulations on pre-Oedipal sexuality (all babies have their first love-affair with their mothers) and the Oedipus complex in boys and girls (complete with castration complex and penis envy). But as Wollheim has pointed out, she makes the process historically limited. The Oedipus complex necessitated by the incest taboo will pass into history when women need no longer be used as exchange objects among men. The question of biologically induced social differences between men and women is thereby begged. There is no apparent reason why the removal of the taboo from incest will alter the biologically created fact that the girl, realising that she is without the phallus, will proceed to envy it (1974, p. 87). Now if that is the way it is, that is the way it is. But, if so, it is difficult to see how Mitchell can envisage the overthrow of patriarchy.

Wollheim, in his criticism of Mitchell, offers the possibility of an alternative kind of account for the development of the

woman in society. He suggests that Freud (and, therefore, Mitchell) got his transferences wrong because of his clinical neglect of the theoretically postulated bisexuality. If it were 'done right', so to speak, the findings of psychoanalysis might indicate that 'what women have suffered from over the centuries is man's inability to tolerate the feminine side of his nature'. This, of course, coincides with the descriptive conclusions of feminists. But Wollheim goes further: 'if this is so, the intellectual task that confronts feminism is to try to trace the cultural and institutional devices which have facilitated the projection of this intolerance onto social forms' (1976, p. 69). Surely the beginning of this task must take us back to the essential postulate of radical feminism: namely that the biological differences between men and women were the first and most binding facilitators. If radical feminism pushes its theoretical development in this direction, to uncover further the implications of biological differences in themselves, and to use psychoanalysis to show how those differences become translated into social meanings, it can produce a forceful explanation of the historical development of patriarchy.

The most thorough attempt at synthesising Marxism and feminism has been made by Sheila Rowbotham. The aim of her most recent work is to show that Marxism is 'useful as a revolutionary weapon for women [by] at once . . . encounter[ing] it in its existing form and fashion[ing] it to fit our particular oppression' (1973, p. 45). She follows this line of thought to good avail in her analysis of women's work as wage labourers and as houseworkers. While her argument is not as systematically worked out as the *New Left Review* debate, her perceptiveness, her willingness to be personally vulnerable, her often poetical descriptions and her method break through the boundaries of her theoretical framework. By alternately getting close to her subject and then backing off she reveals not only the theoretical dimension of female labour but also its subtleties, the way the system works in its day-to-day operation, the means by which women are in turn defeated and find new ways of railing against their situation.

But her insight from an earlier work that Marxism and feminism cohabit in the same space somewhat uneasily being 'at once incompatible and in real need of each other' (1972, p. 246) is not expanded. Substantively she gives full weight to the

viability of patriarchy but she does not attempt to develop any theoretical base for it. This leads her to such statements as capitalism 'has still retained the domination of men over women in society' (1973, p. 122). Aside from endowing capitalism with an almost teleological rationality, this also assumes that ultimately the social relations of production control the fate of patriarchy. Her nod in the direction of biological differences is cursory and speculative: 'the physical weakness of women and the need of protection during pregnancy enabled men to gain domination' (1973, p. 117). While she insists that the relationship between 'dreams, fantasy, vision, orgasm, love and revolution' be studied and taken seriously (1973, p. 44), her framework does not, at this point, provide her with the right questions or concepts; certainly she borrows little, if at all, from radical feminism. At the theoretical level, the synthesis becomes reductionism. It has proceeded out of the *need* of Marxist-feminists for synthesis; it could more properly be called the absorption of feminism by Marxism.

In her interpretation of the findings of Freud, Mitchell developed a theoretical analysis of patriarchy, as a kind of parallel theoretical analysis to her work on women and class. She insisted that the capitalist mode of production and the ideological mode of patriarchy must be analysed *separately* (1974, p. 412):

> To put the matter schematically, in analyzing contemporary Western society we are (as elsewhere) dealing with two autonomous areas: the economic mode of capitalism and the ideological mode of patriarchy. The interdependence between them is found in the particular expression of patriarchal ideology – in this case the kinship system that defines patriarchy is forced into the straight-jacket of the nuclear family. But if we analyze the economic and the ideological situation only at the point of their interpenetration, we shall never see the means to their transformation.

Both the Marxist and the feminist accounts must be used in the analysis of women in society. The first is rooted in the social relations of production and the emergence of private property; the second is rooted in the study of how biological inequalities and differences are transformed into their social meanings and institutionalised. The first requires a socialist revolution; the second, working on the precondition of developing technology,

requires an overturning of that which has been considered 'natural' since the beginning of time and the conscious rediscovery for the individual and for the race of the experience of bisexuality.

THE HISTORICAL TEST

The preceding study of women in the seventeenth century provides a historical confirmation of Mitchell's hypothesis that the economic mode of production and the ideological mode of patriarchy must be analysed separately before the points of intersection are studied. This will become clearer as we look again at the contributions *each* perspective has made to an understanding of the effects of the massive transitions of the seventeenth century on the lives of women.

Perhaps the most important point is that using a Marxist approach made it possible to select the crucial period for study. The transitional period from feudalism to capitalism must be the point of departure for the study of the position of women in capitalist society: not industrialisation, not urbanisation, not modernisation, but the emergence of capitalism. By concentrating upon this period, answers are suggested to some of the unanswered questions raised by other studies on the development of the nuclear family.

The idea that the nuclear family is somehow out of place in capitalist society, as some Marxist writers seem to suggest, can be put to rest. The nuclear family, as we still know it, emerged *with* capitalism. The nuclear family is one of the institutional developments of capitalism just as much as the corporation, the bank or the educational system. If there are some points of friction between the requirements of the family and the requirements of the market, these are contradictions inherent in capitalism; they are not the consequence of capitalism having somehow to cope with a feudal remnant.

On the other hand, the mystery uncovered by such social scientists as Goode and Ariès in separate kinds of research, that the nuclear family somehow preceded industrialisation and was thrown up by unknown sources, is, at least in broad outline, solved. Goode pointed out that 'earlier [i.e. before industrialisation] changes in the Western family system, beginning perhaps with the seventeenth century, may have made that transition to industrialization easier than in other cultures' (1963, p. 370).

Capitalism preceded industrialisation by 150 years; this explains why industrialisation had a family structure suitable to its needs.

Using a Marxist analysis thus permitted the identification of the key moment in the development of the nuclear family. This focused attention on the concomitant changes in the role of women as society passed from feudalism to capitalism. But not only did it show how the changing mode of production changed the lives of women, it also permitted the drawing out of the *differences* in the roles played by women at different points in that mode of production. To take a symbolic example: the feudal structure provided the conditions for Lady Margaret Hoby to keep a diary, women of the yeomanry to leave recipes and millions of peasant women to die leaving no record of their stay on this earth. With the transition to capitalism, and the emergence of the bourgeoisie and the proletariat, these differences crystallised and became polarised into two opposing classes. The women of the bourgeoisie were kept in physical comfort, in idleness and in a state of total dependence. Proletarian women lived out a continuous struggle combining working and mothering in their desperate and often futile struggle to ensure their families' survival.

The Marxist analysis showed, then, the origins of the two main roles women play today, roles which despite some challenge are still reinforced by the structure of the society. The social consequences of these roles provide the copy for the women's pages of newspapers and grist for the feminist and leftist media. Proletarian women of the seventeenth century shared with their successors a dominant place on the welfare rolls, more than their share of deserting husbands, the dilemma of being caught between husband and state haggling over who should pay child support, and the bulk of the most menial and poorly paid jobs. Bourgeois women and their more recent and less fortunate middle-class imitators continue to find their identities as the Mrs John A. Smiths who, though they might put it rather differently than did Mary Astell, are still absolute monarchs only in their own Bosoms (see p. 48). Since most of them can no longer afford servants, the idleness of their predecessors has been replaced with a thoroughly domestic role which expands to fill the day as children grow older.

In summary, the Marxist perspective showed how the mode of production determines the lives of women within their households both by defining the internal structure of those households and

by locating their position in the social system. The Marxist analysis insists that the position of women can only be properly explored through an analysis of the mode of production and, therefore, through an examination of those differences among women which result from their place in the class structure. But a Marxist analysis did not generate questions about the differences between men and women, about the different ideas a society holds with respect to women and men, about how and why those ideas change; questions that deal specifically with female oppression.

While the biological inequality of the sexes is an ahistorical truth, the feminist concept of patriarchal ideology proved susceptible to historical analysis. Since the church has been instrumental in the development and propagation of different forms of patriarchal ideology, its teachings provide a useful index of change. The feminist analysis directed attention, therefore, to the Protestant Reformation for the origins of the form of patriarchal idealogy that we experience today. Studying the changing teachings of the church was no substitute for information about how men and women made love, how they felt about their bodies, whether women experienced orgasm, whether they tried to practice birth control, how successfully and how often they performed abortions, how often they were beaten or raped. But it did draw attention to the role of the church in propagating ideas about female inferiority, about the proper relationship between husband and wife, about love and sexuality. It showed how and why the ideas about these subjects changed during the seventeenth century.

The Protestant embrace of life in the world, its rejection of celibacy, led to a radical reappraisal of the family. The Protestants raised the family from a third-rate place in the moral hierarchy to the status of a 'little church', and an indispensable institution for the rearing and maintaining of the godly. Women were made fit for this new family. While still inferior, they no longer carried the greater share of responsibility for the evilness of humanity. The Protestants enunciated a new image for women, a new conception of their place in the cosmic order, and transformed the ideas about the family and the proper relationship between the sexes; that is, they redefined patriarchal ideology.

The evidence supports the feminist assertion that changes in partriarchal ideology are not merely reflections of the mode of production. For the new Protestant perspective was not fashioned

because of its peculiar appropriateness to capitalism. On the contrary, the preachers of the early seventeenth century were explicitly anti-capitalist. 'In the Country,' charged Bishop Hall,

> 'they censure not the oppressing gentle-man that tyrannizes over his cottagers, incroches upon his neighbour's inheritance, incloses commons, depopulates villages, scruges his tenants to death, but the poor soules that when they are crushed, yield the juyce of tears, exhibit bits of complaint, throw open the new thornes, maintaine the old wounds; would these men be content to be quietly racked and spoiled, there would be peace. (George, 1961, p. 151)

A. G. Dickens confirms through his masterful study, *The English Reformation*, that Puritanism was 'an essentially other-worldly religion, dominated not only by an almost morbid sensitivity but by a real distrust of "modern" capitalist tendencies'. During the period before the Reformation the Puritans 'were more outspoken than any group in their denunciation of usury, economic greed and social injustice' (1964, p. 317).

Yet during this period, a new image for women was emerging. An army of modest, hardworking, loyal and godly wives became the fond dream of the preachers. But their dream did not come true. Through no fault of theirs it was aborted as Protestantism crossed historical paths and became entwined with capitalism. Its particular form of patriarchal ideology was then itself altered, providing a remarkably successful, at least in terms of its persistence, ideological basis for the bourgeois family. Perhaps it would be more reasonable to say that the success of this Protestant perspective over time should be attributed to its adoption and adaptation by the bourgeoisie.

It is to the cross-fertilisation of these two historical processes, and therefore, in the context of this study, to some of the points of intersection between a Marxist and a feminist analysis, that we can finally turn. The interconnection of capitalism and Protestantism has been well documented in other contexts. By looking at capitalism from a Marxist perspective and at Protestantism from a feminist perspective, the particular effects of that conjunction on the family and on the lives of women can be drawn out.

Throughout the Middle Ages the church had laid down precepts for all aspects of society. As Tawney wrote, 'However

Catholics, Anglicans, Lutherans, and Calvinists may differ on doctrine or ecclesiastical government, Luther and Calvin, Latimer and Laud, John Knox and the Pilgrim Fathers are agreed that social morality is the province of the Church, and are prepared both to teach it, and to enforce it, when necessary, by suitable discipline' (1938, p. 23). But the times were changing. A successful challenge to the church's prerogatives was mounted by the bourgeoisie. As Christopher Hill has written, 'the House of Commons, and the class which it represented, had triumphed at every point . . . the sovereignty of Parliament was established, including a de facto sovereignty over the church' (1956, pp. 349–50).

The church did not, however, go away, nor did religion disappear. Just in time it had established a new, and by its own standards, an important arena in which to operate: the Christian home, 'the Seminary of the Commonwealth, seed-plot of the Church, pillar (under God) of the world' (see p. 56). This home, about which the church waxed so eloquent, was still the society in microcosm, the economically productive household of the better-off peasant or craftsman. But the world for which this new and elevated conception of the family had been developed was changing. The economic processes were forcing the less fortunate yeomen and tradesmen into the swelling class of wage labourers. The more successful among them were becoming capitalists increasingly living off the surplus value produced by others. The new household was very different; it was shrinking in many senses. No longer was it a place to produce, rather a place to consume; no longer a place to 'work' but only a place to 'live': a place for private emotions and intimacy, a place for children, a world for women. This was a far different home from the one in which the Protestants had so recently enclosed the woman as good wife. And by a stroke of historical irony, perhaps justice, when the world was divided in two, not only women but religion itself was relegated to the home. The church increasingly would have little to say about how things were produced, but only about how they were used. 'Wealth,' stated Max Weber, '[became] bad ethically only in so far as it [was] a temptation to idleness and sinful enjoyment of life, and its acquisition is bad only when it is the purpose of later living merrily and without care' (1958, p. 163).

Defining private morality, rather than public standards, became the last legitimate interest of the church, and the state continued

to acknowledge the church's right to influence in this sphere. That is, the men of the state and the men of the church combined to control women, within their 'natural' place within the family. Laws against birth control, abortion, divorce, adultery – these were the moral principles which the church could and would continue to defend. As a result, the home became, by inference at first, and later by definition, the centre of morality. The church acquiesced in this belief, and in its corollary: that the world of business was controlled only by 'the new science of Political Arithmetic, which asserts, at first with hesitation and then with confidence, that no moral rule beyond the letter of the law exists' (Tawney, 1938, p. 24).

The Protestant intention that the home be a moral and industrious place in the midst of a godly commonwealth of men went unrealised. Instead, stripped of its productive functions, the home became a spiritual retreat, in need of protection from an, at best, amoral world. This separation continued to add to the ideological importance of the home insisted upon by the Protestants. Descriptions of the home lost the majesty of language conferred by the Puritans and assumed a mawkish tone. The following passage was written in 1920 but quotes the nineteenth-century historian J. R. Green.

In considering our indebtedness to the Puritans, it should never be forgotten by those who value English home life that they gave it to us. 'Home, as we conceive it now,' writes J. R. Green, 'was the creation of the Puritan.' If Puritanism occasioned the 'loss of the passion, the caprice, the subtle and tender play of feeling, the breadth of sympathy, the quick pulse of delight' of the Elizabethan age, 'on the other hand life gained in moral grandeur, in a sense of the dignity of manhood, in orderliness and equitable force. The larger geniality of the age that had passed away was replaced by an intense tenderness within the narrower circle of the home.' Gravity and seriousness reigned there, softened and warmed by family love, until the home of the honest, upright Englishman has become the sweetest and purest thing on earth:

'A quiet centre in a troubled world,
A haven where the rough winds whistle never,
And the still sails are in the sunbeams furled.'
(Flynn, 1920, p. 75)

In a certain sense the Protestant view of women simply did not take. With the rise of capitalism a class of women isolated from production and economically dependent on their husbands had emerged. Their lives came to consist increasingly of leisure and idleness. Whereas once industry and thrift had been inseparable aspects of a husband and wife's productive life together, now their interests diverged: his interest was to make money, hers to spend it. By the end of the seventeenth century bourgeois women were being criticised by the Protestant standards. Their extravagance, idleness, foolishness were sources of gentle parody and stinging satire. *The Spectator* (1710) steered a middle course between these two: 'The toilet is their great scene of business and the right adjusting of their hair, the principal employment of their lives. The sorting of a suit of ribbons is reckoned a very good morning's work and if they make an excursion into a mercer's or a toyshop, so great a fatigue makes them unfit for anything else all the day after' (Phillips, 1926, p. 116).

Women were brought to court for sins of extravagance. 'It was proved that she was very extravagant, and used to pawn her clothes for money' (O'Faolain, 1973, p. 233), read a court statement by Sir John Holt (c. 1700). Pepys was one of the first to record such troubles: 'At home and find my wife of her own accord to have laid out twenty-five shillings upon a pair of pendants for her ears which did vex me' (Phillips, 1926, p. 83).

Mary Astell was a lone feminist hoping to rouse her female readership into an awareness of their position. Her criticisms, though made from the wish to change not disparage women, were similar. Pleading with the Ladies in 1701, she wrote 'Can you be in Love with servitude and folly? Can you dote on a mean, ignorant and ignoble Life? . . . Why won't you begin to think, and no longer dream away your Time in a wretched incogitancy?' (p. 52). The women whom she was addressing were a far cry from those who had been the model for the Protestant conception of the good wife. For the preachers had matched the economic importance of the family with a comparable ideological presence, the economic partnership of husband and wife with a spiritual and emotional relationship. They had, in Haller's words, 'called women to an intensely active existence on the emotional and spiritual as well as the physical and practical level' (1942, p. 257). With the removal of production from the home, that is with the rise of capitalism, the Protestants' image of woman took on a new form which they would have found scarcely recognis-

able. Yet their teachings had by no means been without effect.

Once the spiritual partnership was no longer based on the companionship of working in daily life, the nature of the relationship shifted. The women's enclosure within the home, 'the sweetest and purest thing on earth', coupled with the total involvement of men in the world, led to the reversal of the Catholic view of male spirituality, female carnality; male virtue, female evilness. The Protestants had played an intermediary part in rejecting the conception of woman as evil, and substituting for it that of good wife. But it was not to stop there. By the nineteenth century she became the symbol of 'unfallen humanity'. Her heart 'enshrines the priceless pearl of womanhood . . . before which gross man can only inquire and adore' (Rogers, 1966, p. 189). This conception became, in Rosemary Reuther's words, a kind of secular mariology (1973, p. 129), although there is also a debt to courtly love. The early Protestants would not have admitted to a share in this image-creation. They had not believed that women were naturally saintly. Virtuous behaviour was a continuous daily struggle for everyone, not least for women. Yet they had idealised marital love and the home, and they had enclosed women within the family.

Women's newly discovered goodness came from, and could only be preserved through, isolation from the world. Women came to be seen as pure, innocent, child-like and asexual. Their asexuality also owed a special debt to the Protestants, who had defined, more explicitly than ever before, a single sexual standard based on the non-erotic sexual purity of the marriage-bed on the one hand, and absolute abhorrence of adultery on the other. The double standard, however, after flourishing for centuries, was almost impervious to Protestant teachings; so much so that, during the Interregnum, when adultery was made an offence – and a capital one at that – the law only applied to women (Thomas, 1959, p. 212). The ineffectiveness of the Protestant teachings was compounded by two developments. The separation of work and home, with morality being confined to the latter, put fewer strictures on the behaviour of men outside the home. At the same time, the hardships of working-class life were creating a greatly expanded population of prostitutes and potential mistresses (Thomas, 1959, p. 198). Relationships between these women and the men of the bourgeoisie undermined the Protestant ideal of the faithful husband. To these liaisons were attributed all the mad passion and lust which had so astringently been set

apart from marital sex. While men escaped into these illicit relationships, the purity of conjugality flourished within the bourgeois home.

The religious strictures against adultery proved useful for the need of the bourgeoisie to produce only legitimate children. Female chastity was a priority, wrote Dr Johnson, because 'upon that all the property in the world depends'. The essence of the crime of adultery is the 'confusion of progeny'. Therefore, he added, 'wise married women don't trouble themselves about infidelity in their husbands [since] the man imposes no bastards upon his wife'. Johnson's concession to Protestant teachings that a man who commits adultery 'is criminal in the sight of God' (Thomas, 1959, p. 209) did little to redress the imbalance produced in the sexual standards.

The non-erotic aspect of marital sexuality led the way to the ultimate protection for bourgeois property: the eighteenth century witnessed the triumph of the 'new feminine ideal afforded by Richardson's Pamela [who fainted] at the first sexual advance, and [was] utterly devoid of feelings towards her admirer until the marriage Knot was tied'. Less than a century later came the acceptance that properly brought-up women experienced no sexual feelings. 'Happily for society' the supposition that women possess sexual feelings can be put aside as a 'vile aspersion' (Thomas, 1959, p. 215). Women had finally been cleared of the most serious charge levelled at them by the Catholic Church: the desire and power to seduce men.

Perhaps if any one idea of the Protestants contributed to keeping women within the home in the intervening centuries, it was their marrying of spiritual and conjugal love. Led to this by their desire to legitimate marriage and avoid promiscuity, they developed it at a propitious moment in the history of the family. The economic functions of the family were declining; men were no longer dependent upon the labour of their wives; women no longer had important responsibilities to fulfil within the home.

The elevation of love as the chief ideological underpinning for marriage has been so successful in maintaining the nuclear family as an institution that it appears as a brilliantly executed move by its proponents. Shulamith Firestone, for example, writes that 'romanticism is a cultural tool of male power to keep women from knowing their condition' (1970, p. 139). The Protestants did not, of course, give primacy to love within marriage. While

love may have been 'the marriage vertue which singes Musicke to their whole life' (Haller, 1942, p. 257), it was most certainly not its substance. That was provided by the economic and religious partnership of marriage. When this broke down, however, love was left as a sole legitimate reason for marriage. The elevation of love increased the emotional content of the husband-wife relationship. But for the man, love was still only part, and a small part, of his life. For women it became their *raison d'être*.

> Man's love is of man's life a thing apart,
> 'Tis woman's whole existence.

Women's economic dependence upon their husbands was matched then by an emotional dependence; their sense of self was to come from the reflection in their beloved's eye.

When households were busy and multi-faceted there had been a place for the unmarried woman. With the passing of production from the home, there was no role for her. 'The subject [of surplus women] aroused anxiety, not because the numerical superiority of women was actually greater than previously – the contrary was the case – but because there was no longer a useful place in the family for the surplus women to fill' (Klein, 1963, p. 29). Not being chosen to be a man's wife meant not having a home, not having a place in the world. The Protestant equation of woman = wife ensured an additional psychological burden for single women. Some of these agonies have been documented in the touching account of Victorian governesses in the well-named anthology *Suffer and Be Still* (Peterson, 1972). But there is no need to go back that far to see the pressures on young women to marry, and the difficulties which face those who do not.

Women had to cultivate those qualities which would make them appealing to a man. Puritans had urged that wives be chosen for their godliness, unselfishness, modesty, cheerfulness and industry. In stark contrast, James Fordyce advised in 1766 that 'men of sensibility' desire soft prettiness, fragility and tearfulness in women as well as cowardice. Since 'an intrepid female seems to renounce our aid . . . we turn away, and leave her to herself' (Rogers, 1966, p. 186).

The working-class home provided neither the material nor the spiritual possibilities of retreat from the world. The women were depicted as evil, sexual, dirty, passionate, in contrast to the purity of the bourgeois woman. Without direct access to the means of

production, with totally inadequate wages, a high proportion of them supplemented their income with prostitution (Sigsworth, 1972, p. 80). 'It is, of course, impossible for us to live upon [my wages]' a woman told Henry Mayhew, 'and the consequence is I am obliged to go a bad way . . . I am now pregnant . . . If I had been born a lady, it would not have been very hard to act like one' (O'Faolain, 1973, p. 303). If the chastity of bourgeois women was the Protestant expression of mariology in capitalist society, the majority of women, working women, poor women, sometime prostitutes and their more professional sisters, carried the Catholic ideas of female evilness and seductiveness into the new society. With what Zaretsky (1973, p. 107) has called 'the proletarianization of personal life' (a development which lies nearly two centuries beyond the period with which this study is concerned), the bourgeois ideal of women began to reach down into the working class despite 'its glaring inappropriateness to a life of toil' (Stearns, 1973, p. 113).

Using the two perspectives – Marxist and feminist – separately has enabled us to see some of the different strands which were woven together to alter in a radical way every aspect of woman's life. In the course of one hundred years all the forces were set in motion which brought about a change in the mode of production and a new form of patriarchy. For the home of the bourgeois was a very different place from that of his predecessor on the land, in a craft or in trade. Economically speaking, it was merely a shadow of that largely self-sufficient household. But at the same time the ideas of the Protestant religion were investing the home and family with an unprecedented ideological importance. The partnership of marriage, economic and spiritual, and sweetened with love, had been the Protestant ideal of marriage. With the decline of the economic functions of the home, the spiritual partnership underwent a parallel erosion. Men were spending most of their time in a world untouched by religion, and their image was changing to suit the world of work, business, politics. The marriage was left with only one spiritual partner, the woman. That was no longer a partnership. Spirituality merely became transposed into a quality of the dependent and powerless female member. The implications were dramatic: spiritual was translated into innocent, innocent into child-like. Bourgeois women, mused Reuther, were 'half angel, half idiot' (1973, p. 129).

The Protestant views on the chastity of the marriage-bed collided with the separation of work and home. In that process they became transformed into the twin beliefs of female frigidity and male sexuality. Such men married to frigid women needed an outlet for their 'natural impulse' (Thomas, 1959, p. 198). The impoverished women of the labouring classes were to provide it, becoming themselves the representation of the evil or fallen woman. Love had been conceptualised by the Puritans as combining sensual and spiritual feelings within a conjugal setting. When love between two people was elevated to become the only reason for marriage it was a gross violation of Protestant intentions. Nevertheless, the development and maintenance of a nuclear family useful to capitalist development does owe a heavy debt to the Protestant idealisation of love.

With the separation of work and home, the role of the family in society became obscured. Family life, intimacy, sexuality, love – and women – came to be seen as totally separate from the economic system. So did religion. Moral and ethical principles were shunted into the home, the arena for private life. Men were told how to treat their wives, their children, their parents, but not their workers, their business partners or their customers. Women on the other hand were told how to behave. This relegation of religion to the home gave substance to the growing belief that morality was an aspect of personal relations and, on the other hand, further legitimated the idea that the family played no part in the economy.

Our interest in those events is not simply the interest of the historian. For our approach has revealed how the genesis of the present-day family and the roles that women play within it can be found in the interlocking and overlapping histories of the capitalist mode of production and the Protestant form of patriarchal ideology. This study has borne out the truth of Alice Clark's declaration that 'coming events cast their shadows before them' and that the shadows in the lives of women in the seventeenth century are still those of our contemporary life (1919, p. 296). The working woman with no place to leave her child, the upper-middle-class woman economically and emotionally dependent upon her husband, the privatised nature of the family which resists interference even in the case of battered children and wives, the problematic nature of a loveless marriage, the social and psychological dilemmas for the unattached woman: these were not aspects of Catholic feudal life, but they were emerging

in the seventeenth century and are still matters of personal anxiety and public discussion. A Marxist and a feminist analysis have shown how these particular dilemmas which are manifestations of the position of women in this society can be seen in the context of, and as intrinsically related to, the mode of production, the ideological mode of patriarchy, and their interconnections.

In analysing the position of women in society, we must draw upon these two equally necessary perspectives. Mitchell came to this conclusion through her analysis of class and her study of psychoanalysis. The present study concurs with that finding through an historical analysis of the changing mode of production and the changing forms of patriarchal ideology. It seems to me that there is a major problem with each theoretical position taken on its own.

The feminist assertion that female oppression came first is most assuredly true. But while class exploitation may be an afterthought of human development, it is certainly one with a long and distinguished history. Feminists must take seriously the enormous differences in life-chances between women at different points in the mode of production. Anything else is not only self-delusion but also leads to incorrect strategies for struggling against patriarchy. To prepare for that struggle, we must also become more proficient with the tools at our disposal, in particular the methods of historical and psychoanalytic analysis.

Marxists must consider the consequences for women *in any social system* of bearing the greater burden of perpetuating the species. There is a biological inequality which all the birth control pills and worker-run factories cannot erase. Men have conquered the world because they had nature on their side. The social repercussions of this, how men and women spend their lives, how they experience their sexuality, are translated into privileges not only for rich men but for all men.

Perhaps at some point a marriage between Marxism and feminism may be possible. But a decent period of shacking up, perhaps under the same roof but with separate bedrooms, seems to me to hold out a good deal more promise for arriving at some real understanding both of the differences between men and women and of the differences between women and women. A child conceived now of a union between Marxism and feminism would indeed be ill-begotten, brought into the world out of the need for simplicity and dogma rather than understanding.

Different structures are developing for the overthrow of capitalism and the dismantling of patriarchy. Individually and collectively choices need to be made about where to direct time and energy. But by recognising what is left out of our choices, what we do not select as our own area of work, we will perhaps not only be more tolerant of those who make other choices, but in fact grateful that there are those working on another front. Paradoxically we are in a situation where more than one revolution is needed, but where each can only succeed with the realisation of the other.

Bibliography

Ariès, Philippe (1962), *Centuries of Childhood, A Social History of Family Life* (New York: Random House).

Ashley, Maurice (1963), *The Stuarts in Love* (London: Hodder & Stoughton).

Astell, Mary (1701), *A Serious Proposal to the Ladies for the Advancement of Their True and Greatest Interest* (London: printed by J. R. for R. Wilken, 4th edn).

Astell, Mary (1730), *Reflections upon Marriage* (London: William Parker, 4th edn).

Benston, Margaret (1969), 'The political economy of women', *Monthly Review*, vol. 24, no. 4.

Benson, Margaret and Davitt, Pat (1975), 'Women invent society', *Canadian Dimension*, vol. 10, no. 8, pp. 69–79.

Bernstein, Judy, Morton, Peggy, Seese, Linda and Wood, Myrna (1972), 'Sisters, brothers, lovers . . . listen . . .', in *Women Unite!* (Toronto: Canadian Women's Educational Press), pp. 31–9.

Bradley, Rose (1912), *The English Housewife in the Seventeenth and Eighteenth Centuries* (London: Edward Arnold).

Burris, Barbara (1973), 'The fourth world manifesto', in *Radical Feminism*, ed. Anne Koedt, Ellen Levine and Anita Rapone (New York: Quadrangle/The New York Times Book Co.), pp. 322–57.

Campbell, Mildred (1942), *The English Yeoman* (New York: Barnes & Noble).

Cavendish, Margaret, Duchess of Newcastle (1974), 'From the World's Olio', in *By a Woman Writt, Literature from Six Centuries By and About Women*, ed. Joan Goulianos (Baltimore: Penguin Books Inc.), pp. 55–60.

Chambers, J. D. (1972), *Population, Economy and Society in Preindustrial England* (London: Oxford University Press).

Clark, Alice (1919), *Working Life of Women in the Seventeenth Century* (London: Dutton).

Clark, C. G. (1947), *The Seventeenth Century* (Oxford: Clarendon Press).

Coulson, Margaret, Magas, Branka, and Wainwright, Hilary (1975), 'The housewife and her labour under capitalism – a critique', *New Left Review*, no. 89, pp. 59–71.

de Beauvoir, Simone (1952), *The Second Sex* (New York: Alfred A. Knopf).

Dickens, A. G. (1964), *The English Reformation* (London: Batsford).

Dixon, Marlene (1972), 'Ideology, class and liberation', in *Mother Was Not A Person*, ed. Margaret Andersen (Montreal: Our Generation Press), pp. 227–41.

Dobb, Maurice (1947), *Studies in the Development of Capitalism* (New York: New World Paperbacks).

Draper, Hal (1972), 'Marx and Engels on Women's Liberation' in *Female Liberation*, ed. Roberta Salper (New York: Alfred A. Knopf), pp. 83–107.

Engels, Friedrich (1948), *The Origin of the Family, Private Property and the State* (Moscow: Progress Publishers).

Engels, Friedrich (1958), *The Condition of the Working Class in England*, ed. W. O. Henderson (Oxford: Blackwell).

Everitt, Alan, 'Farm labourers', in *The Agrarian History of England and Wales 1500–1640*, ed. Joan Thirsk (London: Cambridge University Press).

Firestone, Shulamith (1970), *The Dialectic of Sex* (New York: Morrow).

Flynn, John (1920), *The Influence of Puritanism* (Port Washington: Kennikat Press).

Freud, Sigmund (1964), *New Introductory Lectures on Psychoanalysis* (New York: W. W. Norton).

Frye, Ronald Mushat (1955), 'The teachings of classical Puritanism on conjugal love', *Studies in the Renaissance II*, pp. 148–59.

Fussell, G. E., and Fussell, K. R. (1953), *The English Countrywoman: A Farmhouse Social History 1500–1900* (London: Andrew Melrose).

George, C. H. (1971), 'The making of the English bourgeoisie, 1500–1750', *Science and Society*, pp. 385–414.

George, C. H., and George, Katherine (1961), *The Protestant Mind of the Reformation* (Princeton, NJ: Princeton University Press).

George, Margaret (1973), 'From goodwife to mistress: the transformation of the female in bourgeois culture', *Science and Society*, pp. 152–77.

Goode, William (1963), *World Revolution and Family Patterns* (Glencoe: Free Press).

Greer, Germaine (1971), *The Female Eunuch* (Great Britain: Granada).

Haller, William, and Haller, Malleville (1942), 'The Puritan art of love', *Huntingdon Library Quarterly*, V, pp. 235–72.

Hill, Christopher (1956), *Economic Problems of the Church from Archbishop Whitgift to the Long Parliament* (Oxford: Clarendon Press).

Hill, Christopher (1964), 'Work and leisure in pre-industrial society, a discussion', *Past and Present*, no. 29, pp. 63–6.

Hill, Christopher (1965), 'The many-headed monster in late Tudor and early Stuart political thinking', in *From the Renaissance to the Counter Reformation: Essays in Honour of Garrett Mattingly*, ed. C. H. Carter (New York: Random House), pp. 296–325.

Hill, Christopher (1969a), *The Century of Revolution* (London: Sphere Books).

Hill, Christopher (1969b), *Reformation to Industrial Revolution* (Harmondsworth: Penguin Books).

Hill, Christopher (1969c), *Society and Puritanism in Pre-Revolutionary England* (London: Panther Books).

Hill, Christopher (1972), *The World Turned Upside-Down* (London: Temple Smith).

Hobsbawm, Eric (1954), 'The crisis of the seventeenth century – II', *Past and Present*, no. 6, pp. 44–63.

Hoby, Lady Margaret (1930), *The Diary of Lady Margaret Hoby 1599–1605*, ed. Dorothy M. Meads (New York: George Routledge).

Hole, Christina (1953), *The English Housewife in the Seventeenth Century* (London: Chatto & Windus).

Hoskins, W. G. (1953), 'The rebuilding of rural England 1570–1640', *Past and Present*, no. 4, pp. 44–59.

Hoskins, W. G. (1957), *The Midland Peasant* (London: Macmillan).

Hunt, Judith, and Hunt, Alan (1974), 'Marxism and the family', *Marxism Today*, vol. 18, no. 2, pp. 59–61.

Hunt, Judith (1975), 'Women and liberation' *Marxism Today*, Vol. 19, no. 11, pp. 326–37.

James, Margaret (1967), *Social Problems and Policy During the Puritan Revolution 1640–60* (New York: Barnes & Noble).

Janeway, Elizabeth (1971), *Man's World, Woman's Place, A Study in Social Mythology* (New York: William Morrow).

Johnson, James T. (1969), 'English Puritan thought on the ends of marriage', *Church History*, vol. 38, pp. 429–36.

Klein, Viola (1963–4), 'Industrialization and the changing role of women', *Current Sociology*, pp. 27–33.

Koedt, Anne (1973), 'The myth of the vaginal orgasm' in *Radical Feminism*, ed. Anne Koedt, Ellen Levine and Anita Rapone, (New York: Quadrangle/The New York Times Book Co.), pp. 198–207.

Koedt, Anne, Levine, Ellen, and Rapone, Anita (eds) (1973), *Radical Feminism* (New York: Quadrangle/The New York Times Book Co.).

Langdon-Davies, John (1927), *A Short History of Women* (New York: Viking Press).

Laslett, Peter (1965), *The World We Have Lost* (New York: Charles Scribner's Sons).

Magas, Branka (1971), 'Theories of Women's Liberation', *New Left Review*, no. 66, pp. 69–92.

Marshall, Dorothy (1954), 'The old Poor Law 1662–1772', in *Essays in Economic History,* ed. E. M. Carus-Wilson (London: Edward Arnold), pp. 295–305.

Marx, Karl (1906), *Capital. A Critique of Political Economy*, Vol. I, (Chicago: Charles H. Kerr).

Marx, Karl, (1935), *Value, Price and Profit* (New York: International Publishers).

Marx, Karl (1948) *The Communist Manifesto*, ed. Harold J. Laski (London: George Allen & Unwin).

Marx, Karl (1964), *The Economic and Philosophic Manuscripts of 1844*, ed. Dirk J. Struik (New York: International Publishers).

Marx, Karl (1973), *The Grundrisse* (Harmondsworth: Penguin Books).

Marx, Karl, and Engels, Friedrich (1969), *Selected Works VI* (Moscow: Progress Publishers).

McGregor, O. R. (1957), *Divorce in England* (London: Heinemann).

Millet, Kate (1969), *Sexual Politics* (New York: Doubleday).

Mitchell, Juliet (1971), *Women's Estate* (Harmondsworth: Penguin Books).

Mitchell, Juliet (1974), *Psychoanalysis and Feminism* (New York: Pantheon Books).

Morgan, Irvonway (1965), *The Godly Preachers of the Elizabethan Church* (London: Epworth Press).

Morton, Peggy (1972), 'Women's work is never done', in *Women Unite!* (Toronto: Women's Educational Press), pp. 46–68.

Notestein, Wallace (1954), *The English People on the Eve of Colonization 1603–30* (New York: Harper).

O'Faolain, Julia, and Martines, Lauro (1973), *Not in God's Image* (New York: Harper & Row).

Peterson, M. Jeanne (1972), 'The Victorian governess: status incongruence in family and society' in *Suffer and Be Still*, ed. Martha Vicinus (Bloomington, Ill.: Indiana University Press), pp. 3–19.

Phillips, M. and Tomkinson, W. S. (1926), *English Women in Life and Letters* (London: Benjamin Blom).

Pink, Peter (1973), 'Marxism and the family', *Marxism Today*, pp. 284–6.

Plummer, Alfred (1972), *The London Weavers' Company 1600–1970* (London: Routledge & Kegan Paul).

Powell, Chilton (1917), *English Domestic Relations 1487–1653* (New York: Russell & Russell).

Power, Eileen (1965), 'The position of women' in *The Legacy of the Middle Ages*, ed. C. G. Crump (Oxford, Clarendon Press), pp. 401–33.

Reed, Evelyn (1972), *Is Biology Woman's Destiny?* (New York: Pathfinder Press).

Reiff, Philip (1961), *Freud: The Mind of the Moralist* (Garden City, New York: Doubleday).

Reuther, Rosemary (1973), 'The cult of true womanhood', *Commonweal*, 9 November, pp. 127–32.

Rogers, Katherine (1966), *The Troublesome Helpmate, A History of Misogyny in Literature* (Seattle: Washington Paperbacks).

Rowbotham, Sheila (1972), *Women, Resistance and Revolution* (New York: Vintage Books).

Rowbotham, Sheila (1973), *Woman's Consciousness, Man's World* (Harmondsworth: Pelican Books).

Schlatter, Richard B. (1940), *The Social Ideas of Religious Leaders 1660–88* (New York: Octagon Books).

Schucking, Levin (1929), *The Puritan Family: A Social Study from the Literary Sources* (New York: Schocken Books).

Secombe, Wally (1974), 'Housework under capitalism', *New Left Review*, no. 83, pp. 3–24.

Secombe, Wally (1975), 'Domestic labour – reply to critics', *New Left Review*, no. 94, pp. 85–96.

Siegel, Paul N. (1950), 'Milton and the humanist attitude toward women', *Journal of the History of Ideas*, II, pp. 42–53.

Sigsworth, E. M., and T. J. Wyke (1972), 'A study of Victorian prostitution and venereal disease', in *Suffer and Be Still*, ed. Martha Vicinus, (Bloomington: Indiana University Press), pp. 77–99.

Stearns, Peter N. (1972), 'Working class women in Britain 1890–1914', in *Suffer and Be Still*, ed. Martha Vicinus (Bloomington, Ill.: Indiana University Press), pp. 100–20.

Stenton, Doris (1957), *The English Woman in History* (London: George Allen & Unwin).

Stone, Lawrence (1965), *The Crisis of the Aristocracy 1558–1640* (Oxford: Clarendon Press).

Tawney, R. H. (1912), *The Agrarian Problem in the Sixteenth Century* (London: Longman, Green).

Tawney, R. H. (1938), *Religion and the Rise of Capitalism* (Harmondsworth: Penguin Books).

The Status of Women in Canada (1970), Report of the Royal Commission.

Thomas, Keith (1958), 'Women and the Civil War sects', *Past and Present*, no. 13, pp. 332–52.

Thomas, Keith (1959), 'The double standard', *Journal of the History of Ideas,* XX, pp. 195–216.

Thorton, Alice (1974), 'The autobiography of Alice Thorton', in *By a Woman Writt, Literature from Six Centuries By and About Women,* ed. Joan Goulianos (Baltimore: Penguin Books), pp. 30–53.

Trotsky, Leon (1970), *Women and the Family* (New York: Pathfinder Press).

Walzer, Michael (1965), *The Revolution of the Saints* (Cambridge, Mass.: Harvard University Press).

Watkins, Owen (1972), *The Puritan Experience* (New York: Schocken Books).

Weber, Max (1958), *The Protestant Ethic and The Spirit of Capitalism* (New York: Charles Scribener's Sons).

Wollheim, Richard (1975), 'Psychoanalysis and feminism', *New Left Review*, vol. 93, pp. 61–9.

Wright, Louis B. (1935), *Middle Class Culture in Elizabethan England* (Chapel Hill: University of North Carolina Press).

Zaretsky, Eli (1973), 'Capitalism, family and personal life', *Socialist Revolution*, nos 13–14, pp. 69–125.

Index